IMAGES
of America

THE RUSSIAN
RIVER

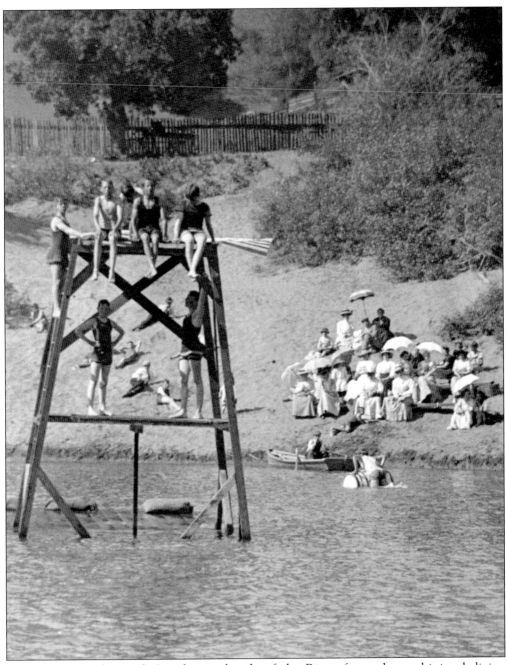

Monte Rio's Sandy Beach, on the north side of the River, featured a multi-tiered diving structure, 1911. (Lowry photo, courtesy of the Monte Rio Historical Society.)

IMAGES
of America

THE RUSSIAN
RIVER

Simone Wilson

ARCADIA
PUBLISHING

Published by Arcadia Publishing
Charleston SC, Chicago IL, Portsmouth NH, San Francisco CA

Printed in the United States of America

Library of Congress Catalog Card Number: 2002103216

For all general information contact Arcadia Publishing at:
Telephone 843-853-2070
Fax 843-853-0044
E-mail sales@arcadiapublishing.com
For customer service and orders:
Toll-Free 1-888-313-2665

Visit us on the Internet at www.arcadiapublishing.com

CONTENTS

ACKNOWLEDGMENTS

Guerneville historian John Schubert generously made his expertise and his extensive photo collection available for this project. Many others also donated their time, photographs, and encouragement, including Darlene Speer, Dave Henry of the Forestville Historical Society, Barbara Hadden of the Monte Rio Historical Society, Monte Rio resident Lee Torr III, Harry Lapham of the Sonoma County Historical Society, Vonna Holz and Eric Stanley at the Sonoma County Museum, and Ginger Hadley and the rest of the staff at the Guerneville Library. Special thanks go to Keith Ulrich, my editor at Arcadia Publishing, for guiding this book through the dark and tangled wood of publishing. Thanks also to David Bolling, my former editor at the late great *Santa Rosa News Herald*, for sending me out to the River with rubber boots and a loaded Pentax to cover the 1986 flood. And of course, to my husband, Creighton Bell, for his patience during the months when I filled the house with photos, notes, and computer print-outs and wrestled them into a book.

INTRODUCTION

The Russian River begins in the hills north of Mendocino County. It rushes past Ukiah and Hopland, slows down a little at Cloverdale, and meanders past Healdsburg on its way to the sea, 110 miles from its source. But when people hereabouts say they live on the Russian River—or even just "The River"—they mean the region of riverbanks and deep shade under the redwoods, from Forestville on down to the Pacific ocean at Jenner.

Native Americans, arriving over 5,000 years ago, camped and fished along the lower River, but they mostly built their villages on the hills above, in the warm oak woodlands. The Russians, whose outpost on the coast at Fort Ross lasted from 1812 to 1841, explored the Russian River Valley and established one of their farms at Willow Creek. The Mexican era saw one rancho, El Molino, at the eastern end of the redwood belt.

It took the lure of timber to bring a growing population to the dense woods, first at Big Bottom (later called Stumptown and finally Guerneville). Towns crystallized around the mills at Guerneville, Monte Rio, and Duncans Mills, and in the 1870s the timber boom prompted businessmen to finance railroads to haul those logs away. Once the railroad threaded through the woodlands, tourists from San Francisco discovered that the region was a paradise for summer camping. After the big trees were cut, other businesses filled the now-sunny spaces: the Korbel brothers laid out vineyards and became premier champagne makers, townspeople planted gardens, and one enterprising Guernevillian even raised award-winning tobacco.

Small resorts and multi-story hotels sprang up along the rail lines, and entrepreneurs sold cottages to families who came for the whole summer. The towns developed a seasonal rhythm, with a summer boom time followed by a sleepier winter when the tourists departed. As the timber began to vanish at the start of the 20th century, tourism emerged as the main business activity. Monte Rio built a seven-story hotel with the county's first elevator. Beaches and dance halls had their best eras in the 1920s and '30s, when Big Bands came to play in Rio Nido and all the towns had roller rinks, dance halls, and music far into the night.

Tourism went into decline in the 1960s, when improved highways lured Bay Area tourists to Lake Tahoe. But many old resorts—some elegant, some funky—hung on, and others opened as tourism rebounded in the 1970s. Counter-culture people with back-to-the-land visions moved into the area in the '60s. Gay and lesbian residents added their numbers to the River's eclectic mix, helping revive many of the businesses and resorts.

Today only one mill, Berry's at Austin Creek, remains as a reminder of the area's logging heritage. But the thriving inns, canoe rentals, restaurants, and resorts link the River's heritage with its modern role as a haven from the rush of urban life.

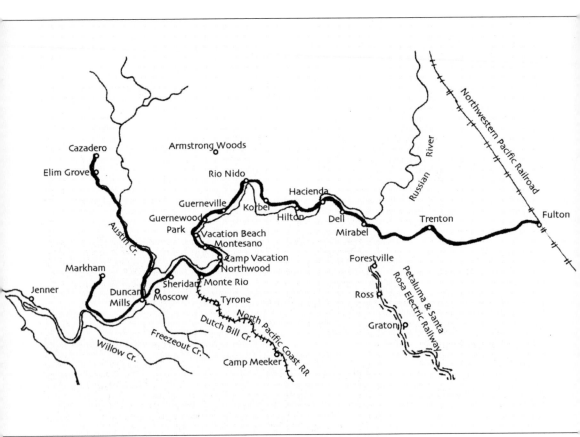

The lower Russian River takes a westward turn before flowing through the redwood region. Railroads connected the areas east and south of the River with the towns of Forestville, Guerneville, Monte Rio, Duncans Mills, and Cazadero.

Further Reading

Anyone eager to learn more about Russian River history can start by consulting the following sources, some of which are still in print, and all of which are available at local libraries. In addition, the archives at the Monte Rio Historical Society and the Guerneville Library are available to the public:

C. Raymond Clar's *Out of the River Mist* (3rd edition, 1984); John Schubert's *Guerneville Early Days* (1997); Fred Stindt's *Trains to the Russian River*; Harvey Hanson's *Wild Oats in Eden* (1962); and Simone Wilson's *Sonoma County—The River of Time* (2nd ed., 1999).

One

INTO THE WOODS

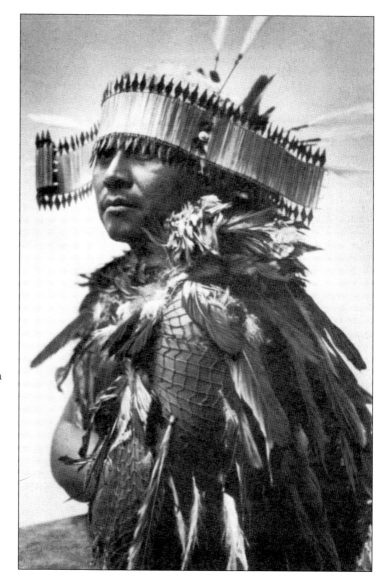

A Pomo dancer with typical ceremonial headgear poses, *c.* 1900. The first people to arrive in the north coast region, at least 5,000 years ago, were the Southern Pomo and the Kashaya Pomo. The Kashaya called themselves "The People from the Top of the Land." Both groups preferred the sunny oak woodlands; neither inhabited the dark woods along the Russian River, although the Southern Pomo had a temporary camp called *ciyole* ("shady place") near present-day Guerneville. The Kashaya population is now centered at Stewart's Point near the coast. (Courtesy of the Hearst Museum of Anthropology, University of California, Berkeley.)

The first Whites to explore the lower River were the Russians, who from 1812 to 1841 occupied the coast between Bodega Bay and their main outpost at Fort Ross, ten miles above the mouth of the River. While the Pomo knew the River as Shabaikai (the Snake, probably because of all its curves), the Russians called it Slavianka—the Russian Girl. The era is recreated every July for the Fort's Living History Day. (Photo by Simone Wilson.)

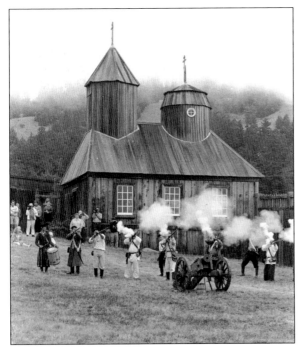

Members of the Fort Ross Interpretive Association fire their muskets for Fort Ross' Living History Day. The Russians came to California to hunt sea otters and also to grow wheat for their Alaskan colonies. They established three inland farms, including the 100-acre Kostromitinov Ranch, on the south side of the Russian River near Willow Creek. Their naturalists explored the river valleys, collecting and naming specimens of local flora, including the California poppy, *Eschscholzia californica*. They also collected local handicrafts like exquisite Pomo baskets. Today the world's largest collection of Pomo baskets is in St. Petersburg. (Photo by Simone Wilson.)

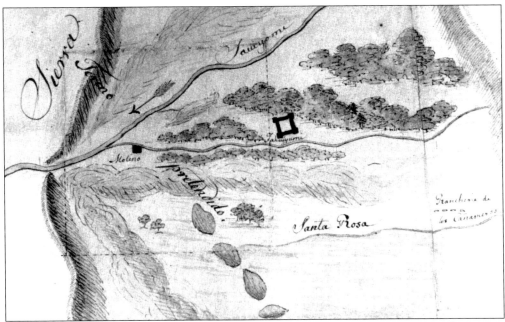

The Mexican era didn't affect the lower River except in Forestville. Sea captain John Rogers Cooper married Gen. Mariano Vallejo's sister Encarnation, and in 1833 acquired El Molino ("The Mill") Rancho, shown here in a *diseño, c.* 1840. Cooper, who also owned a prosperous rancho at Monterey, set up the state's first power-operated commercial sawmill in 1834; a flood destroyed it in 1841. The mill site was the black spot near the confluence of the Russian River (top) and Mark West Creek (center). The larger square to its right was a short-lived colony from Sonoma Mission. The stream in the lower half of the map is Santa Rosa Creek, and the blobs near the bottom represent the Laguna de Santa Rosa. (Courtesy of John Schubert.)

The Mexican government, alarmed that the Russians had acquired a foothold on the California coast, hurried to establish ranchos to prevent the Russians from expanding inland. Occasionally a Mexican official would travel to the fort to invite the Russians to depart, and the Russians would politely refuse—a scene recreated at the Fort's Living History Day (right). Then representatives of the two outposts—each at the farthest edge of their country's territory—would settle down to practical matters, like trading Mexican wheat for Russian tools and boats. Neither empire prevailed: the Russians left in 1841. Mexico's Alta California territory was swallowed up by Americans from the east and ceded to the U.S. in 1848. (Photo by Simone Wilson.)

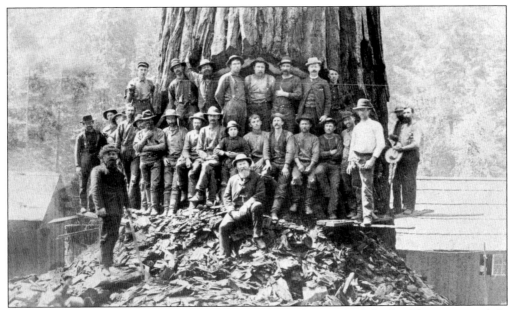

A crew of loggers nestles in a giant redwood cut, April 21, 1889. J.A. Gould is at upper left; William Fraser, superintendent of the Duncans Mills Land and Lumber Co., is seated at center. With the start of the California Gold Rush, lumbermen began to scout around for sources of timber to construct the growing city of San Francisco. While southern Sonoma County was a source of food—potatoes, butter, meat—the vast tracts of towering redwoods provided the perfect source of wood for the expansion of San Francisco. (Barney Gould collection, courtesy of the Sonoma County Historical Society.)

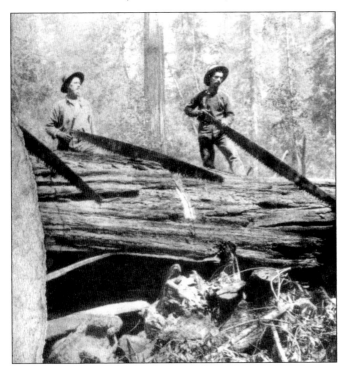

The trees that the timbermen felled along the Russian River were among the tallest in the world, many well over 300 feet high. Today the tallest remaining redwood on the River is the 336-foot Clar tree, named for the Clar family that owned the property downstream from Guerneville. Here two sawyers take the tools of their trade to a felled redwood. Eventually lumbermen realized that coast redwoods—*sequoia sempervirens*—will resprout, creating a new forest of second-growth redwoods which can also be logged. (Courtesy of John Schubert.)

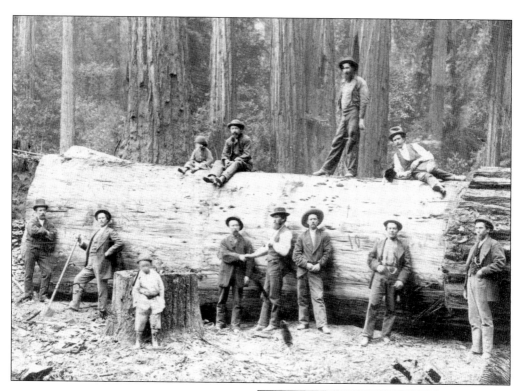

Loggers pose with their prey, a prime first-growth redwood tree, in the area around Big Bottom, later called Stumptown (for obvious reasons) and finally Guerneville. The figure in white in front of a stump is a Chinese worker. This photo was one of a set of Northern California scenes sold by photographer Edgar Cherry. (Courtesy Sonoma County Museum.)

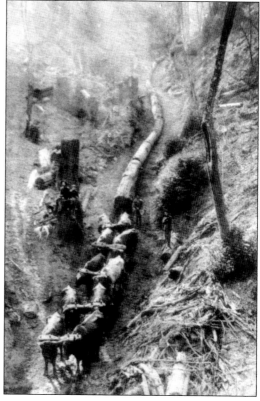

Once the loggers had felled the biggest trees on the valley floor, crews worked the steep canyons, using teams of oxen to drag the trunks down from the heights. They would often line the route with wood, creating a "drag road" that made it easier to skid the logs downhill. Lumbermen could also move a felled tree with a "steam donkey," chaining the log to the engine's rotating head, which then dragged the tree into position. (Courtesy of John Schubert.)

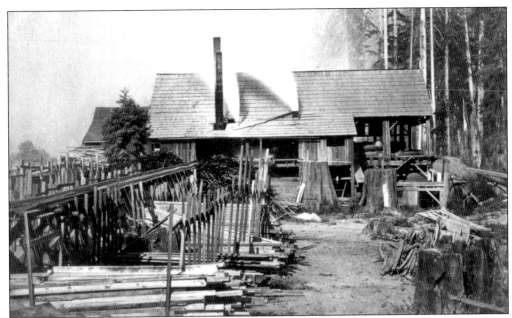

The area's biggest mill was started by the partnership of J.W. Bagley, Tom Heald, George E. Guerne, and W.H. Willets. It was located on Fife Creek, roughly where the Guerneville Safeway is now. At the time of this 1872 photo, it was the Guerne and Heald mill; by 1880 it was the Guerne and Murphy mill. In 1892 D.L. Westover and shipping magnate Robert Dollar bought it. When the mill's last log was milled on February 2, 1901, the owners invited J.W. Bagley to guide the log through the saw. (Joseph H. Downing photo, courtesy of John Schubert.)

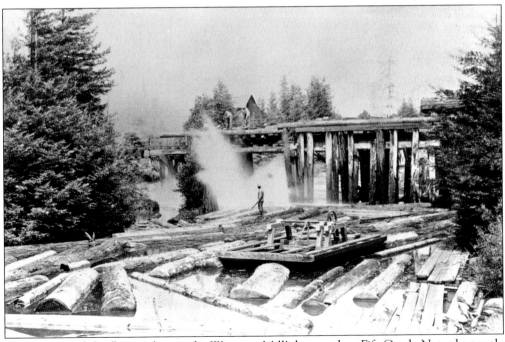

Workers guided the floating logs at the Westover Mill's log pond on Fife Creek. Note the trestle in the background. (J. Ross photo, courtesy of the Sonoma County Historical Society.)

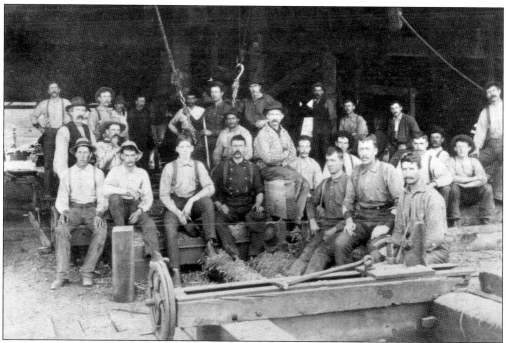

Mill hands at the Guerne and Murphy mill, 1887, included O.O. Cobb, Bert Bagley, Henry Klein, O.E. Pells, and (in front on the right) Jack Starrett. (Courtesy of John Schubert.)

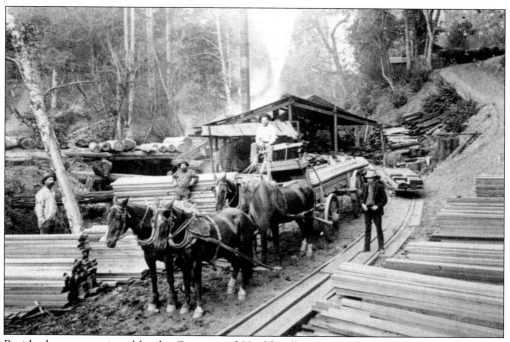

Besides large operations like the Guerne and Heald mill, many smaller mills turned out lumber. Some were in Pocket Canyon south of Guerneville. Another was the Livreau and Ely mill owned by Joseph Livreau and George Washington Ely, half a mile up Livreau Creek. Above is a fairly typical small logging operation near Guerneville, c. 1895. (Courtesy of John Schubert.)

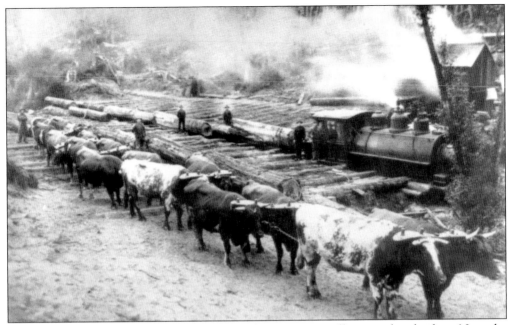

A dozen yoked oxen could drag trees a short distance to a mill or a railroad siding. Note the perpendicular timbers on the ground, which formed the skid road. (Courtesy of John Schubert.)

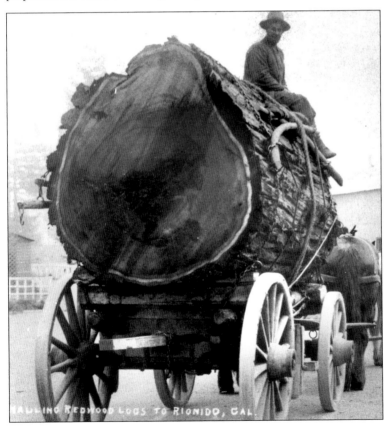

HAULING REDWOOD LOGS TO RIONIDO, CAL.

Early logging operations relied on oxen and wagons to move logs and lumber, like this horse-drawn wagon carting a trunk to Rio Nido. The coming of the railroad would change all that. (Lark and Warne photo, courtesy of John Schubert.)

Two

TRACKS AND
WHISTLESTOPS

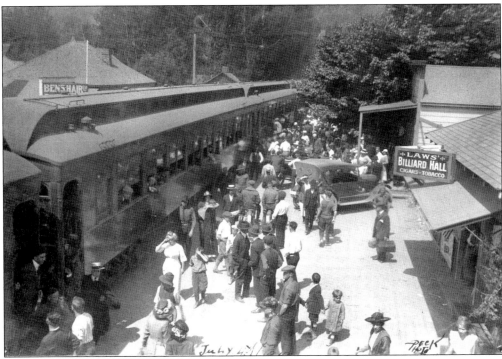

Railroads came to the Russian River in the mid-1870s. Originally built to haul away the lucrative timber, the trains almost at once became an agent of social change. Towns crystallized along the rail lines, and a flourishing tourist trade, unforeseen by the train's boosters, eventually rivaled the timber industry and outlasted it. Towns grew up around the mills, the largest being at Big Bottom, later called Stumptown and finally Guerneville. The other towns of the lower River—Forestville, Rio Nido, Monte Rio, Duncans Mills, and others—all had their own character, shaped by terrain and transport. Here people saunter alongside the train near the station in Guerneville on July 4, 1914. (Charlie Peck photo, courtesy of Darlene Speer.)

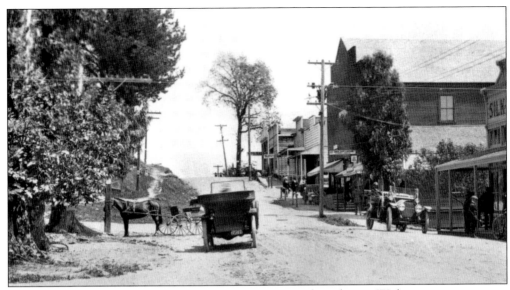

Forestville is on the eastern edge of the Russian River's redwood zone. With more open country for hops and apples, it was more an agricultural center than the other communities of the lower River. Here is Front Street sometime after 1910, looking east; the two-story building was at that time the Oddfellows Hall. The two autos are Cadillacs owned by the Ross brothers. At far right is the general store Tom Silk ran from 1905 to 1947; it also served as post office and the town's branch of the Analy Savings Bank. In winter, Silk would fire up the store's woodstove early every morning so kids could warm themselves before heading off to school. (Courtesy of Forestville Historical Society.)

Gladys Clark, Kenneth Templeman, and Wilma Clark (Arnett) stand near Johnson's Hotel (right background), which was on the site of today's Carr's Drive-in. The hotel was later moved down by the Petaluma and Santa Rosa Electric Railway station and renamed the Electric Hotel. The Clark girls are the daughters of town butcher William Clark. (Photo by Bert Jewett, courtesy of the Forestville Historical Society.)

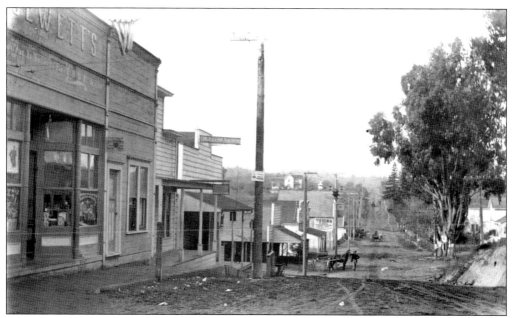

Looking west along Forestville's Front Street, one can see the town's principal businesses on the south side of the street, as well as the hill in the distance where the road climbs to today's Mirabel Road. On the left is Jewett's drug store. Note the eucalyptus trees on the right. Imported from Australia after the Gold Rush, eucalyptus trees became a favorite tree for lining roads and creating windbreaks. (Courtesy of the Forestville Historical Society.)

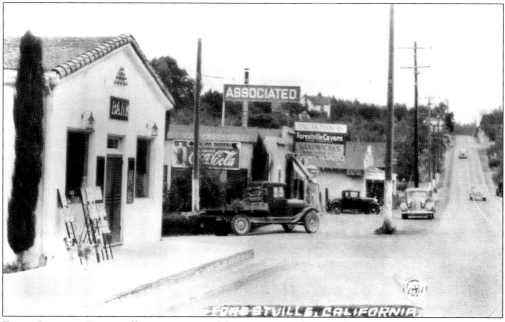

Front Street in Forestville passes several businesses and ascends to Mirabel Avenue, c. 1936. The bank at far left, with a tile roof, is where Silk & Sons was. Just past the bank was the Forestville Cavern, serving sandwiches, beer, and Italian dinners. (Courtesy of the Forestville Historical Society.)

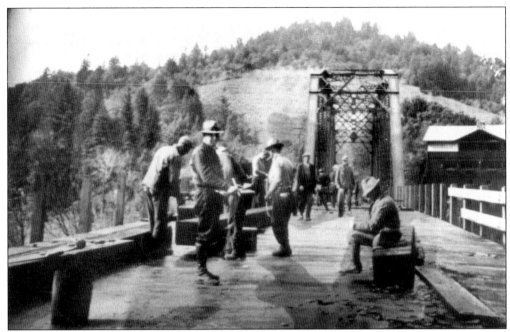

The Forestville area benefited from two separate rail lines. The broad gauge from Santa Rosa came down the River, crossed the river at Cosmo (later Hacienda), and proceeded west to Guerneville. After train service stopped, workmen (above) tore out the tracks in 1936 and converted the span to auto traffic. It remained a one-lane bridge until it was widened in 1947. Note the Hess house at the far right, which can still be seen today. Henry Hess was a shipping magnate who owned a fleet of lumber schooners and lumberyards. (Courtesy of the Forestville Historical Society.)

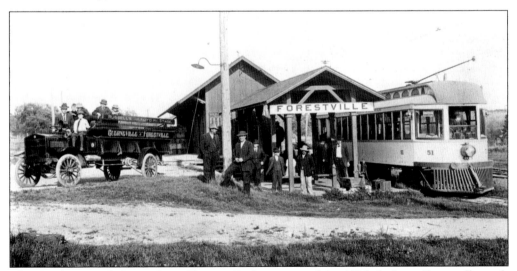

The Petaluma and Santa Rosa Electric Railway arrived in 1905, linking Forestville with Sebastopol and beyond. Access to wider markets led to the growth of apple packing plants. Standing by the depot are, from left to right, Robert Templeman, Tom Gillespie, Lewis Close, Tom Silk, Sylvester "Dump" Faudre, and Jim Johnson, owner of the Electric Hotel. (Courtesy of the Forestville Historical Society.)

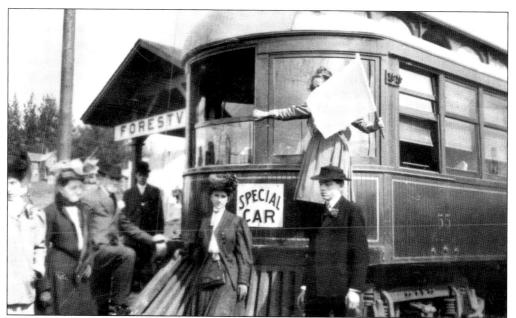

Locals celebrated the opening of the P&SR line at Forestville's depot. Fruit-packing houses like the Gravenstein Apple Growers Union and Seton & Hamilton thrived because the electric railway provided easy transport to markets. Wagons also brought gravel from the river at Mirabel up to the depot. (Courtesy of Forestville Historical Society.)

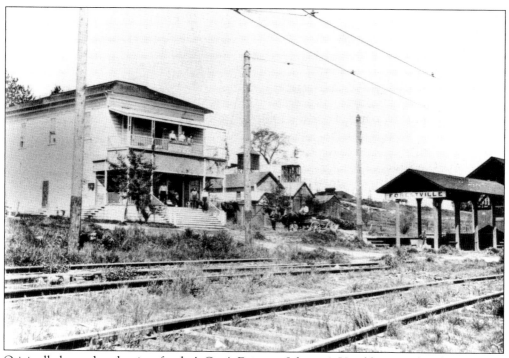

Originally located at the site of today's Carr's Drive-in, Johnson's Hotel became the Electric Hotel when it moved downhill to the corner of First Street and Packinghouse Road. The hotel was just up the slope from the electric railway depot. (Courtesy of the Forestville Historical Society.)

Just down the hill from Forestville was Mirabel, with its own resort and dance hall, pictured above. The other side had a balcony overlooking the beach. (Courtesy of the Forestville Historical Society.)

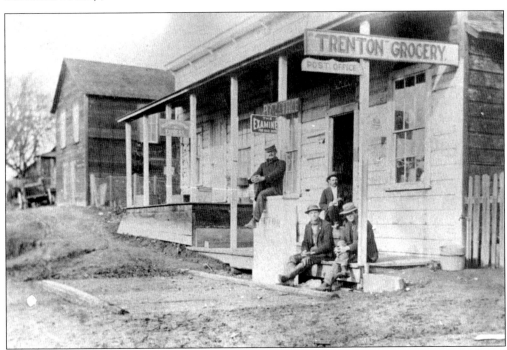

Residents lounge on the steps of the Post Office at Trenton, just east of Mirabel on the broad gauge line, c. 1910. Although not quite on the Russian River, Trenton functioned as a outlying community of Forestville, and Forestville shopkeepers like butcher William Clark paid regular calls to the small hamlet. Trenton had its own railway station, a rectangular building about 15 feet long. (Courtesy of the Sonoma County Museum.)

Rio Nido summer visitors pose by NWP tracks, August 4, 1929. By the 1930s and '40s, Rio Nido's narrow canyons had several hundred homes, many owned by San Francisco police and firemen. Near the tracks was a 10-acre resort—complete with hotel, rental cabins, dance floor, and soda fountain—owned by Harry Harris and his sons, Herb and Clare (who later bought Johnson's Beach). The view here is west toward Guerneville. A road built parallel to the tracks in the 1920s also connected Rio Nido (formerly called Eagle's Nest) with Guerneville. Before that, the road to Guerneville went through Canyon Seven and connected with Mines Road (now Armstrong Woods Road). Today's River Road follows the old NWP right-of-way. (Courtesy of John Schubert.)

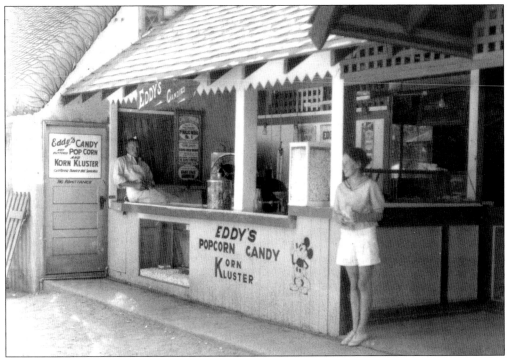

Kids took their pocket money to Eddy's candy store in Rio Nido. Although Guerneville was only a mile away, Rio Nido functioned as its own little enclave, complete with beach, cabins, entertainment, and dance hall. (Courtesy of John Schubert.)

Summer living in Rio Nido involved making yourself comfortable outdoors, c. 1925. (Photo by John "Shorty" Parkins, courtesy of John Schubert.)

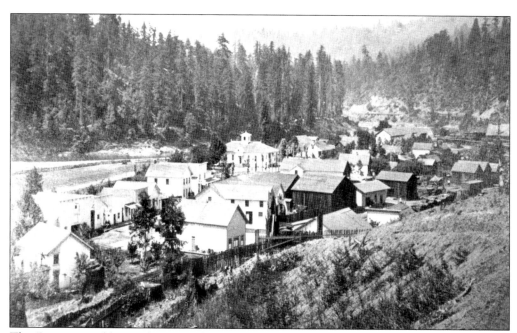

The River is visible on the upper left in this shot of Guerneville, June 10, 1882. Looking southwest, Connell's livery stable is on the left; the Guerne mill is at far right. The school, in the center of town, is the large white building with a belfry. In the mid 1870s the town had roughly 200 people, 2 stores, a hotel, and a saloon. Ten years later the numbers had swelled to 600. (Courtesy of John Schubert.)

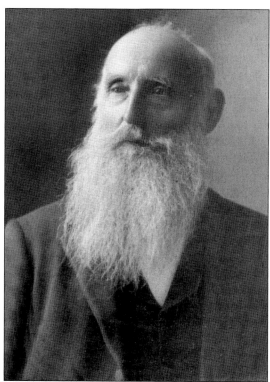

John Washington Bagley (1827–1906) brought the first milling equipment into the region in August 1865. He and his partners, George E. Guerne, Tom Heald (brother of Healdsburg founder Harmon Heald), and W.H. Willets, logged timber for pioneer R.B. Lunsford, who had settled in the area in 1860. Mill partners came and went, and by 1880 the mill was known as Guerne and Murphy's. Bagley became the first postmaster in 1870, when the early name Stumptown was dropped in favor of Guerneville. A man with many hats, Bagley ran the local store, pulled teeth, surveyed land, and served as town sexton and undertaker. (J.W. Ross photo, 1902, courtesy of John Schubert.)

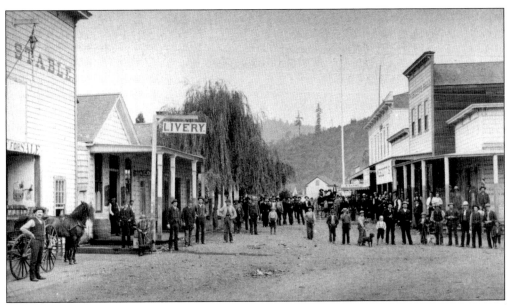

Townsfolk assembled on First Street, looking west, possibly for the December 11, 1887, ascent of Professor E.W. Smith's air-ship (hot-air balloon). Local historian Ray Clar commended Smith for taking off in the winter "when there was no serious chance of setting fire to the mountains." At far left is David Connell's stable. (Courtesy of John Schubert.)

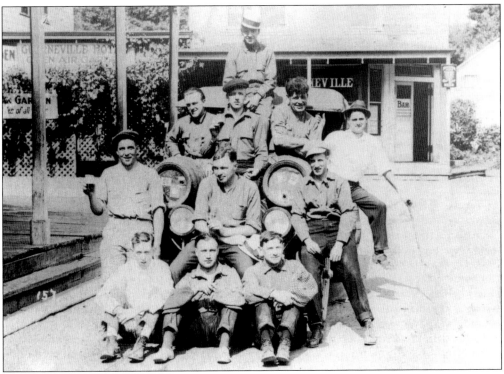

The tailgate party isn't a new phenomenon, judging from this 1917 group in front of the Louvre saloon, looking east. (Courtesy of the Sonoma County Museum.)

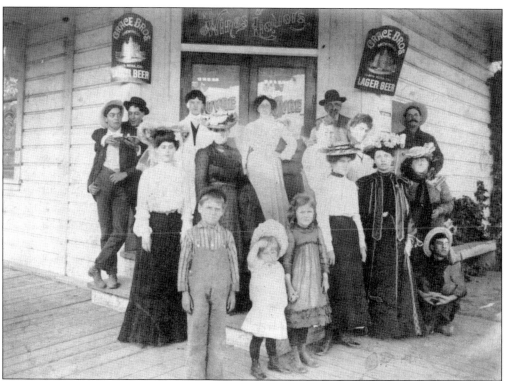

Everyone in Guerneville eventually ended up at the Louvre corner, c. 1900. (Courtesy of John Schubert.)

Antoinette and Omar O. Cobb posed with their dog Jack, c. 1900. Cobb's department store, built of corrugated iron, opened around 1907. The store was variously Cobb and Bagley's, then O.E. Cobb's Central Supply, Cobb & Starret, and then Sampson's. After the 1919 fire, Omar's widow Antoinette built a modern post office on Main Street across from the meat market. The Neeley family took over the mercantile store in 1946; it closed in 1987. (Courtesy of John Schubert.)

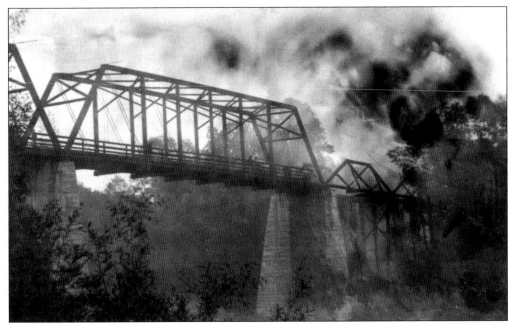

Before the railroad reached Guerneville in 1877, all the milled lumber bound for Santa Rosa went south through Pocket Canyon. Wagons reached the south side of the River via temporary bridges or summer fords. In 1885 the county agreed to fund a permanent bridge linking the town with Pocket Canyon. The 1885 bridge had a roadbed of wooden planks, which could catch fire, as they did here, c. 1915. The view is from town, toward the southeast. (Courtesy of Darlene Speer.)

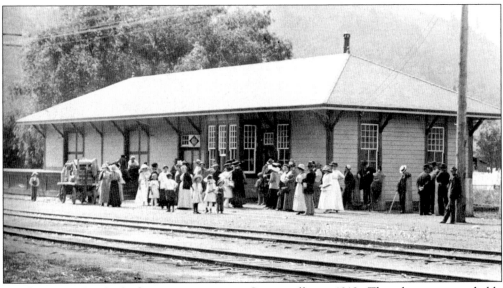

Northwestern Pacific built a new station at Guerneville in 1912. The photo was probably taken when the building was brand new; the Guerneville sign hasn't been added yet. After the railroad ceased in 1935, the building served as Luttrell's meat market and was torn down in 1961. (Courtesy of John Schubert.)

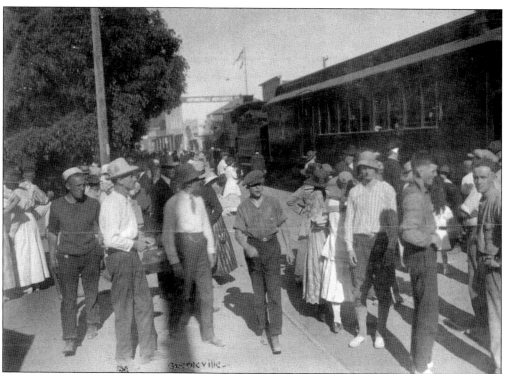

A crowd gathers at the Guerneville depot, c. 1914. The white building in the center background is the Guerneville Mercantile. (Charlie Peck photo, courtesy of Darlene Speer.)

Lizzie Armstrong Jones, photographed in 1898 at the time of her marriage to Parson Jones, was the daughter of landowner James B. Armstrong. As early as 1891, Colonel Armstrong proposed setting aside a grove of old-growth (i.e. unlogged) redwoods north of Guerneville as a park. Armstrong's heirs finally sold the property to the county in 1918. In 1934 the State acquired it, creating Armstrong Woods State Park, now adjoining Austin Creek State Park. From 1933 to 1941, a crew of the Civilian Conservation Corps (CCC) stationed at Camp Armstrong built the park's original buildings, as well as its Forest Amphitheater, which became a popular spot for weddings, plays, and concerts. (Courtesy of the State Department of Recreation and Parks.)

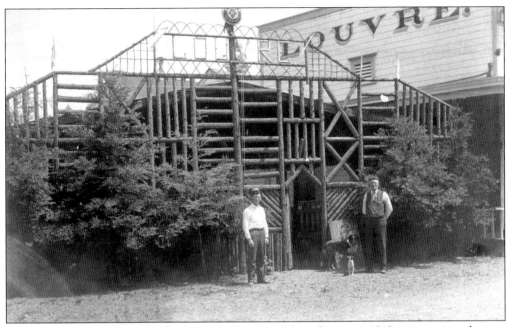

The Louvre garden, next to the Louvre saloon on Main Street, *c.* 1910, was a nice place to escape the heat of the summer sun. (Courtesy of John Schubert.)

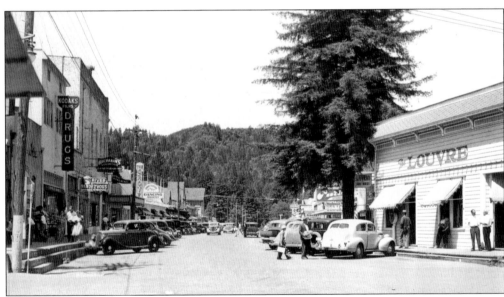

In this view of Main Street Guerneville, looking west, *c.* 1938, the Louvre is on the right. This rebuilt Louvre building at the corner of Main and Cinnabar still stands but lacks the porch and posts of the Louvre's previous incarnations. Later the building was Stumptown Annie's Pizza and today is the video store. On the left were the drug store, River Rendezvous, Buchanan's sandwiches, the Grove dance hall, and Gori's Tavern. The high, stepped curb in front of the drug store is still there. (Courtesy of John Schubert.)

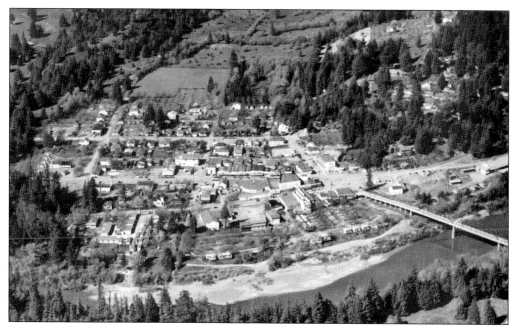

In this aerial view of Guerneville, c. 1940, the 1922 bridge is at lower right. The round roof in the center is the top of the Grove Dance Hall.

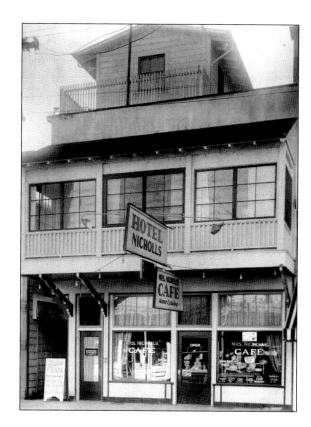

Hotel Nicholls on First Street had a cafe on the ground floor that served steaks, chops, and snacks. Toasted sandwiches were 30¢; burgers were 20¢ apiece. The door on left is the entrance to Dr. Bertram Green's office. The hotel burned down in 1947. (Courtesy of John Schubert.)

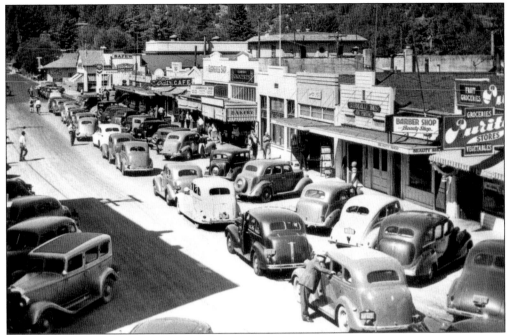

Cars line up on Guerneville's Main Street, 1937, for the opening day of the highway between Guerneville and Northwood. New sections of River Road followed the former railroad route. The route south from Guerneville through Pocket Canyon was paved in 1927. (Courtesy of John Schubert.)

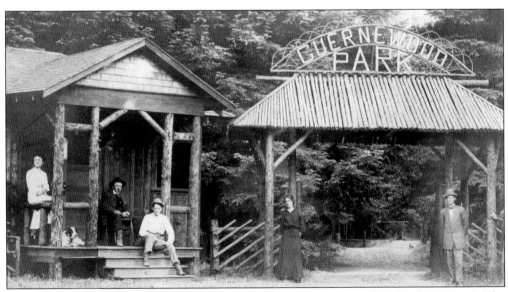

George E. Guerne (in dark coat) sits on the porch of the Guernewood Park office, c. 1910. The view is to the south. Guerne tried unsuccessfully to interest the state in creating a park there, and in 1883 his acreage was logged. After that, the spot became a campground; each unit had a raised wooden tent platform and iron woodstove. Down near the beach were a store, dance hall, and boxball concessions. The site of the gateway is just east of today's Dubrava condos. (Courtesy of John Schubert.)

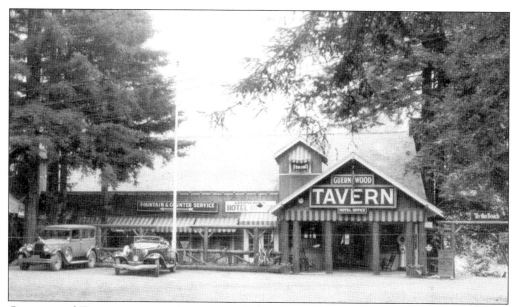

Guernewood Tavern was a popular watering hole, c. 1930. The arch at the far right leads to the beach. (Courtesy of John Schubert.)

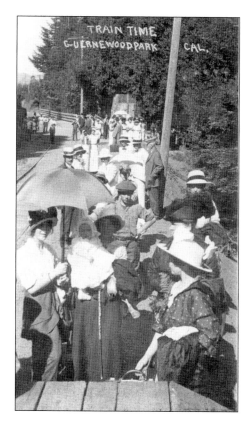

Ladies with their parasols protecting them from the summer sun await the train in Guernewood Park, July 1914. The train tracks in the upper left are where River Road is now. For over 20 years, Guerneville remained the terminus of the broad gauge railroad, but in 1902 the tracks were extended through Guernewood Park to Camp Vacation (near today's Northwood), increasing the tourist traffic there. The tracks reached Monte Rio in 1909. (Courtesy of John Schubert.)

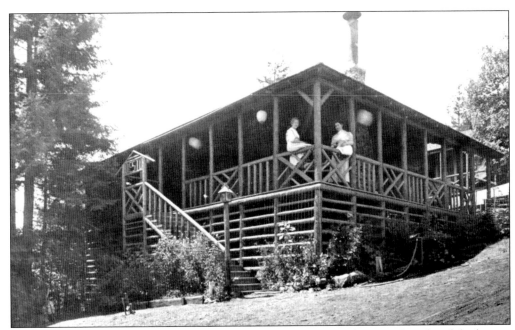

Builders in Guernewood Park and other River communities used materials at hand for houses and stores. The Desto Cottage in Guernewood Heights, photographed *c.* 1908, used pole redwood construction. Japanese lanterns completed the effect. The house was built by Fred de Lappe, a doctor from Modesto. The two women in white on the porch are daughters of George Guerne. The one on the right is probably Edith Guerne de Lappe, holding her daughter Maxine (Lonsdale) de Lappe. (Courtesy of John Schubert.)

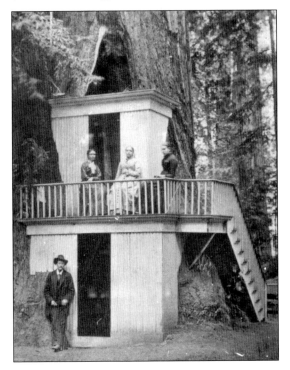

One of Guernewood Park's unique structures was this two-story treehouse, photographed on June 12, 1882. The 300-foot-high redwood supporting it was 54 feet in circumference. The lower room was 14 by 18 feet, the upper room 8 by 9. The woman in the center in white on the balcony is Ellen Bagley. (Downing collection, courtesy of John Schubert.)

Three

ON DOWN THE RIVER

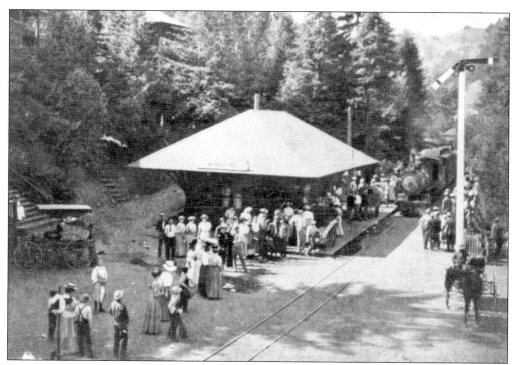

The railroad was the social and commercial lifeline of Monte Rio. The narrow gauge from Marin County went through Tomales, Valley Ford, and Occidental and first reached Monte Rio in September 1876, depositing tourists and hauling away lumber. By 1900 the mills had closed and Monte Rio nearly became a ghost town. But in November 1909, NWP's standard gauge tracks crossed the river near Northwood and continued west into Monte Rio and Duncans Mills, bringing new waves of tourists. By 1910, Monte Rio's summer population hovered around 15,000, and the town boasted five major hotels, three dance halls, and numerous guest cottages. This locomotive is arriving from Duncans Mills, coming into the station at the foot of Starrett Hill, along what is now Moscow Road. (Courtesy of Darlene Speer.)

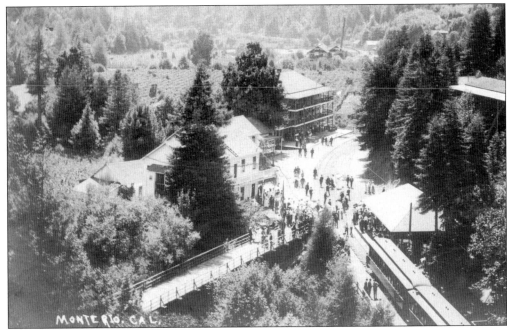

MONTE RIO. CAL.

The train to Duncans Mills, at lower right, is just leaving the station in downtown Monte Rio, at the bottom of Starrett Hill. The building with balconies in the background is the Russell Hotel. At lower left is the south end of the pre-1934 bridge. The broad and narrow gauge trains both traveled to Duncans Mills along the same route via a three-track system: the broad gauge used the outer rails, while narrow gauge trains used the inner rail and a single outer one. (Courtesy of John Schubert.)

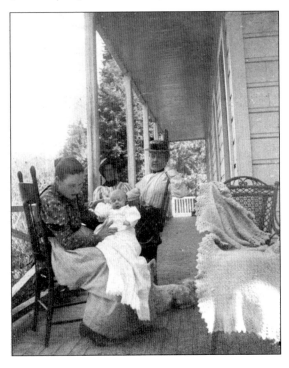

Mrs. Starrett (front) sits on the porch, holding young Robert Russell Starrett, August 21, 1899. (Courtesy of the Monte Rio Historical Society.)

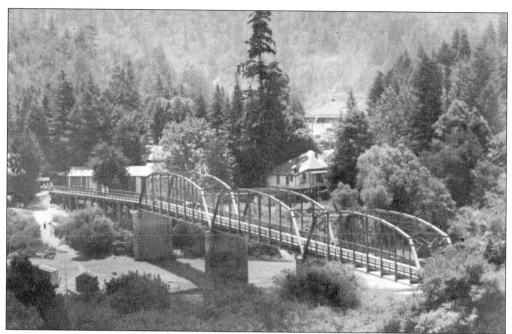

Bridges were vital links in getting goods and people across the river, especially during winter. Bridges at Hacienda, Northwood, and Duncans Mills were originally railroad bridges, while the bridges at Guerneville and Monte Rio allowed wagons and later cars to get across the water in rainy months. The old Monte Rio Bridge (above) was slightly downstream from the current one, which was built in 1934. (Courtesy of John Schubert.)

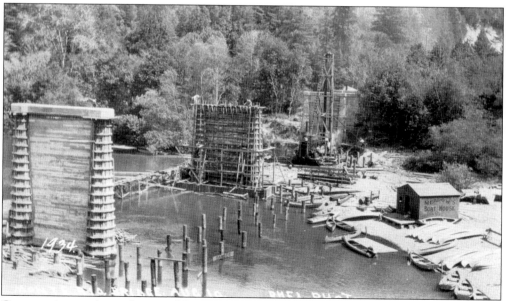

Construction work on the new Monte Rio Bridge, August 10, 1934, dwarfs Meadows' Boat House on the south bank of the river. Charlie Meadows used boat launches to ferry vacationers from the railway terminus at River Landing (near Northwood) to the beaches and resorts of Monte Rio. (J.B. Rhea photo, courtesy of John Schubert.)

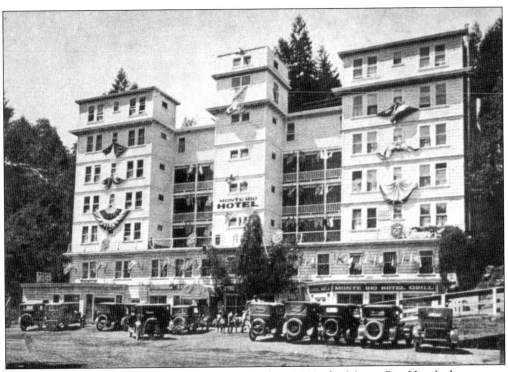

Built c. 1901, the Monte Rio Hotel, shown here in the 1920s, had a unique claim to fame that earned it a place in Robert Ripley's *Believe It or Not* series. Because it was built against the side of Starrett Hill, guests could enter any floor from the hill, making every floor a ground floor. Originally the hotel had five floors; owners later added stories six and seven. It was also the first building in the county to have an elevator. The hotel was torn down in 1935, around the time the railroad also vanished from the River scene. (Courtesy of John Schubert.)

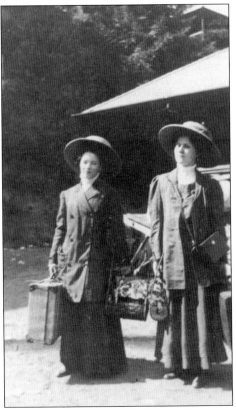

Two lady travelers are pictured lugging their bags from the Monte Rio depot. Considering their heavy coats, it is not yet the height of the summer season. (Courtesy of the Monte Rio Historical Society.)

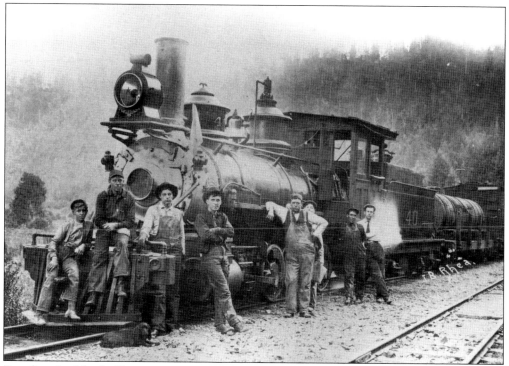

Standing by North Shore engine #40 in Monte Rio are, left to right, George Carr, Bob Rutherford, Fred Lambert, Frank Donahue, Sam Dunlap, unidentified, Manuel "Chick" Garcia, and unidentified. (J.B. Rhea photo, courtesy of the Sonoma County Historical Society.)

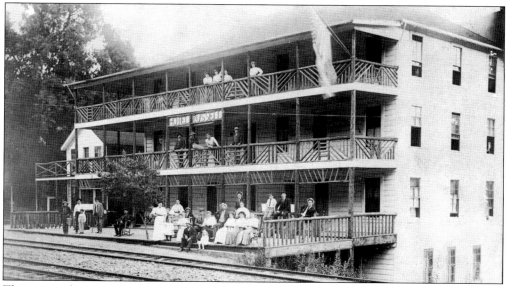

The town of Monte Rio weathered the decline of the timber industry by catering to urban tourists, who had easy access to the River via rail lines. Besides the majestic seven-story hotel, local accommodation included the four-story Sully's Hotel, and Hotel Russell, above, pictured here in the 1920s. Smaller guesthouses with only a few rooms also flourished. Note the tracks in the foreground. (Courtesy of John Schubert.)

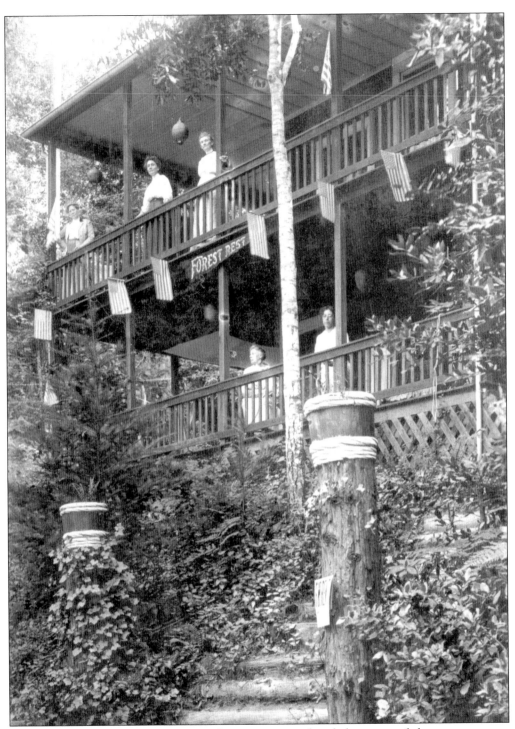

As the tourist industry grew, inns and guest cottages lined the route of the narrow gauge from Occidental to Monte Rio. The Forest Rest resort in Camp Meeker, above, with its rustic look and wide balconies, is typical of rest houses throughout the region. (Courtesy of the Sonoma County Museum.)

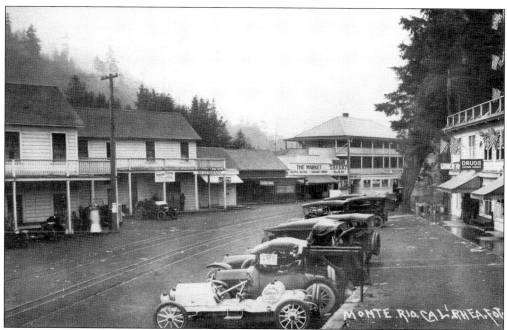

Photographer J.B. Rhea set up his tripod in front of the Monte Rio Hotel to get this shot of downtown Monte Rio. It appears on a postcard sent July 14, 1915, from E. Starrett to a friend in Santa Rosa. The view is looking south toward Camp Meeker, along what is now Bohemian Highway. The white building in the central background is LaFranchi Hotel. Note the triple-tracks on the road, which allowed both standard and narrow gauge trains to use the same route. (Courtesy of the Monte Rio Historical Society.)

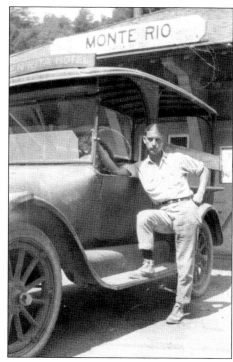

Monte Rio's hotels and guesthouses sent private conveyances—first wagons and later autostages—to the depot to collect travelers. This driver came to pick up guests for the Glen Rita Hotel, early 1920s. (Courtesy of the Monte Rio Historical Society.)

41

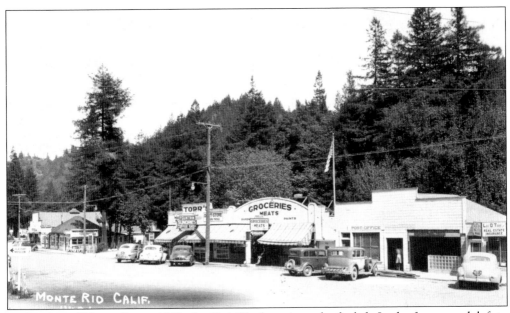

In this shot of Monte Rio, c. 1940, the Pink Elephant is on the far left. In the foreground, left to right, are Torr's Fountain and Coffee Shop, the fishing tackle shop, grocery store (with a single gas pump out front), post office, and Torr's Realty. (Courtesy of John Schubert.)

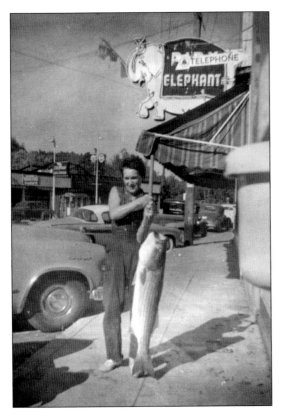

Walking down the sidewalk with the day's groceries takes on new meaning when you live by a river. Toni Latham totes a big fish in downtown Monte Rio, c. 1955. Note the sign for the Pink Elephant bar in the background. Bar owner Charlie Rickett's white-top 1953 Studebaker is parked in front. Across the street is the Chevron station. (Courtesy of the Monte Rio Historical Society.)

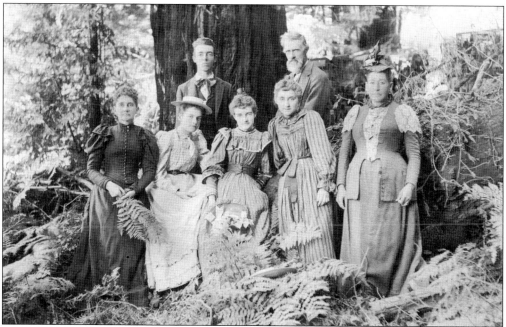

The Sheridan and Rien families lived between Monte Rio and Duncans Mill. In this August 23, 1894, photo are, left to right: (front row) (?) Rien, Ida Carey, May Rien, Mom, Edna Robinson Sheridan (wife of Charles Sheridan), Mrs. (?) Culver; (back row) (?) Rien and John Rien. (Alice Sheridan Ballard collection, courtesy of John Schubert.)

The post office and store were at the heart of the hamlet of Villa Grande (originally called Mesa Grande), on the south side of the river between Monte Rio and Duncans Mill. Villa Grande still maintains a distinct identity. (Courtesy of the Monte Rio Historical Society.)

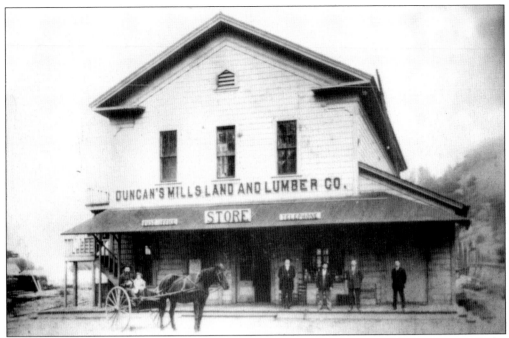

Duncans Mills was essentially a mill town. Brothers Samuel and Alexander Duncan started a mill near the coast and shipped their lumber from Duncans Landing. Alexander Duncan built a new mill upriver at what became Duncans Mills. The train, which arrived in 1876, was a big boost for the town; at its peak Duncans Mills had about 100 people with a hotel, express office, and four saloons, including Orr's, a favorite with the loggers. The store above belonged to the logging company, Duncans Mills Land and Lumber Co. DeCarly's store north of the highway dates from about 1870. Town matriarch Jane DeCarly (1907–1995) had the store remodeled in 1979 but kept its old-fashioned decor. (Courtesy of the Monte Rio Historical Society.)

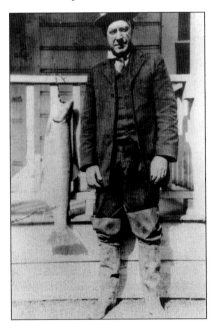

Edward Raynes, doctor at Duncans Mills, had good luck at his favorite fishing hole. (Courtesy of Monte Rio Historical Society.)

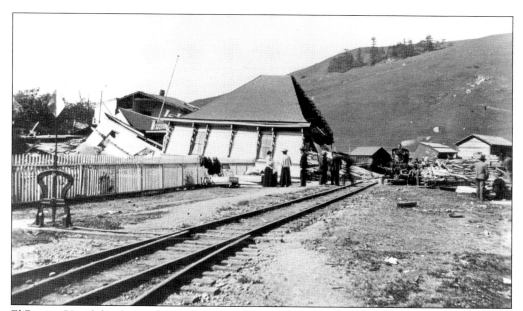

El Bonito Hotel, by the tracks in Duncans Mills, collapsed in the April 18, 1906, earthquake. In Guerneville, the quake toppled chimneys and damaged Noel Tunstall's livery. The only deaths in the River area were at the Great Eastern Quicksilver Mine, where falling rock killed three miners. (Courtesy of Sonoma County Historical Society.)

Travelers enjoy a watermelon feed along the broad gauge line at Duncans Mills, 1926. By the mid-1920s the timber was depleted, a decline aggravated by a September 1923 fire that swept from near Guerneville to the sea. The loss of timber cut into railway business, as did auto traffic. No train robbers operated in the River area, but a bronze plaque outside the Blue Heron Inn celebrates renowned stage robber Black Bart, who held up local stages in 1876 and 1880. Bart left poems at the scenes of his crimes and signed himself "Black Bart, the PO-8." James Sheridan, whose father had homesteaded near Duncans Mill, saw the fugitive bandit emerge from his barn one morning in the early 1880s. (Courtesy of John Schubert.)

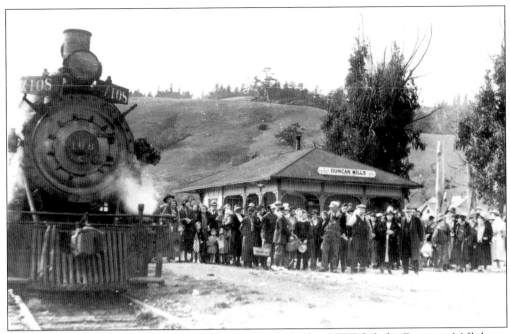

On November 14, 1935, townsfolk waved goodbye as the last NWP left the Duncans Mill depot (the narrow gauge had departed in 1926). In the 1970s, Arnold "Swede" Wallen bought the 1907 depot and meticulously restored it, turning it into a museum. He also bought most of the rest of the town and revived it with western-style shops and cafes. Today the whole town is a historic district. (Hasek photo, courtesy of John Schubert.)

Silas Ingram and his wife established a resort for hunters on Austin Creek c. 1870. When it burned down a couple of years later, they rebuilt at what was originally called Ingram's, then Austin, and finally Cazadero. Ingram also used Chinese labor to build Old Cazadero Road, so tourists could reach his resort from Guerneville. When the railroad reached Cazadero in 1886, Ingram built a two-story hotel. The Trosper family, which homesteaded north of Cazadero in 1862, built a resort in 1898 with a dance floor and a dining room for 100 guests. Nearby resorts were Miller's Retreat and Camp Henrietta. (Courtesy of the Sonoma County Historical Society.)

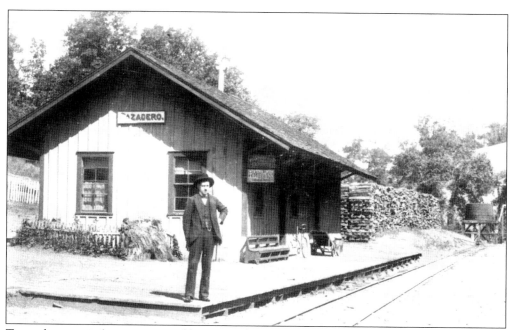

To reach more timber reserves, rail lines were built north along Austin Creek to Cazadero. Note the stacks of wood, used to keep the locomotives going, behind the Cazadero depot. Redwoods love rain, and Cazadero is the rainiest place in the county (the second rainiest in the state) with an average of 85 inches. Its highest recorded rainfall was 143 inches in 1937. (Courtesy of the Sonoma County Historical Society.)

Pictured here, left to right, are Annie McCandless, Dorothy Speckter, and Alice Marra—they went for a jaunt at Cazadero on a flat car carrying cord wood. The narrow gauge made its last trip from Cazadero on September 9, 1926. Broad gauge service took over the route, but the last train to Cazadero ran on July 31, 1933. When the final train departed, the town held a mock funeral procession. Cazadero historian Bob Schneider, then 15 years old, carried a Montgomery Ward catalogue (in place of a Bible). Other kids carried a toy train on a stretcher to mark the sad occasion. (Courtesy of Harry Lapham.)

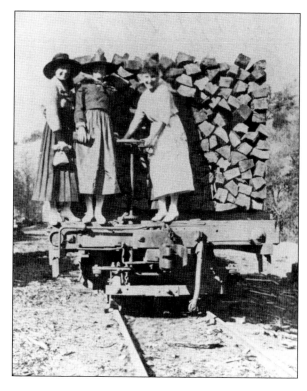

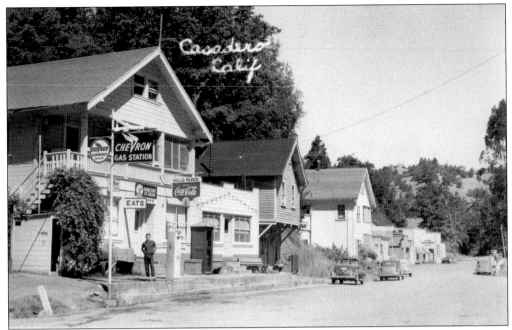

Most of Cazadero's stores were on the west side of the main road, facing the railroad yard. After the train departed, Berry's sawmill was built in 1941 on the site of the railroad turntable. Berry moved the mill down to Highway 116 in 1979. (Courtesy of John Schubert.)

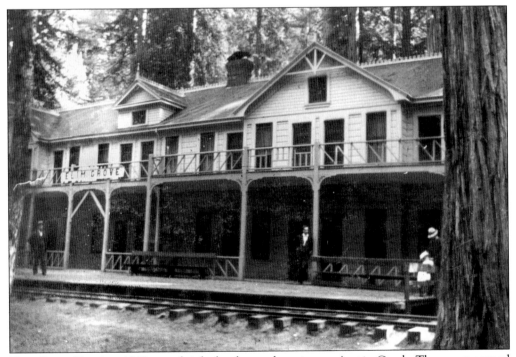

Elim Grove Hotel, c. 1902, stood right by the tracks going up Austin Creek. The resort earned its name (mile spelled backward) for being one mile shy of Cazadero, the northern end of the branch line. (Courtesy of John Schubert.)

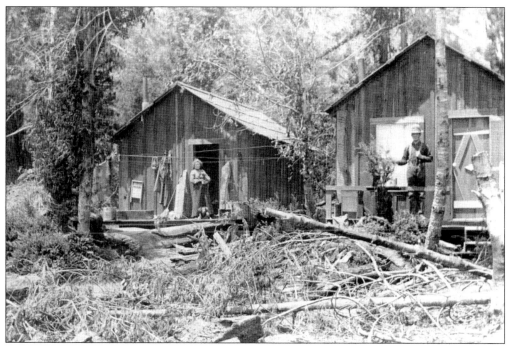

George and Clara Titus lived in the cabin on the left, *c.* 1900. The cabins were at the Charles E. Fuller mill near Markham's. (Photo by George Titus, courtesy of the Sonoma County Historical Society.)

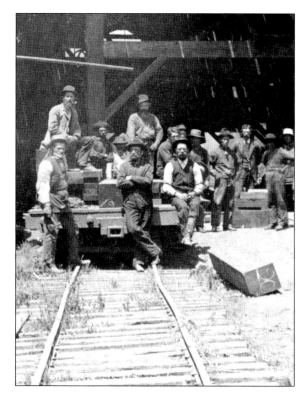

A branch of the narrow gauge crossed the river and ran up to Markham's mill. Owner Andrew Markham (in front at far left, with white shirt sleeves) stands with his crew at the mill. (N.R. Davidson photo, courtesy of the Sonoma County Museum.)

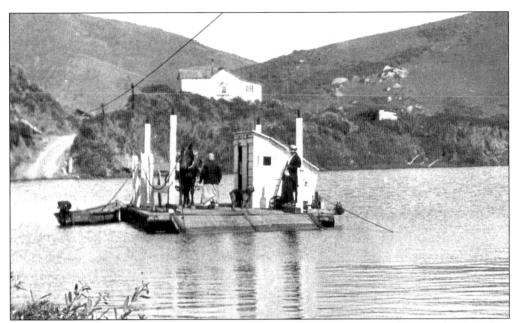

Alexander Cuthill operated the Bridgehaven ferry across the River at the mouth of Willow Creek, upstream from today's Highway One Bridge. It was the only way for wagons and autos to travel along the coast from Bodega Bay to Jenner. (Courtesy of the Sonoma County Museum.)

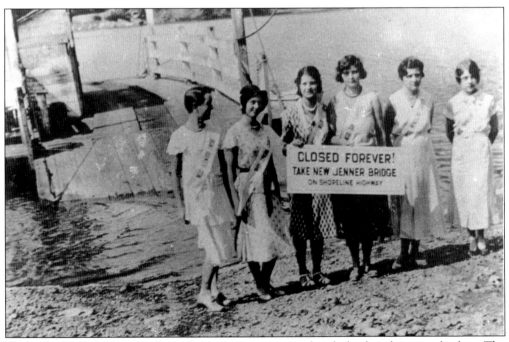

When the Highway One Bridge at Bridgehaven was completed, the ferry became obsolete. The sign says: "Closed forever! Take new Jenner Bridge on Shoreline Highway." The young women celebrating the event include Alice Gonnella, Alice Poulter, and, at far left, Alice Main of Santa Rosa, Miss Redwood Empire. (Courtesy of Harry Lapham.)

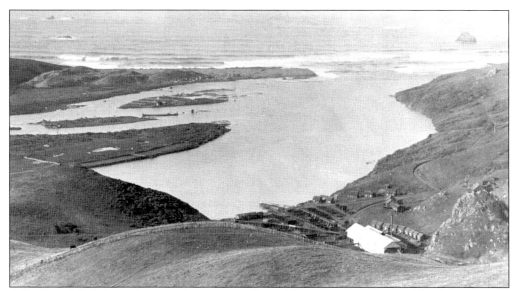

A.B. Davis' California Lumber Company mill, c. 1904, was near the mouth of the Russian River, where the town of Jenner is now. The spit at the top of the picture is at Goat Rock Beach, now part of Sonoma Coast State Beaches, a state park formed in 1934. The tongue of land in the middle left is the lower half of Penny Island. In December 1859, Healdsburg dentist Elijah K. Jenner filed a claim for the island. In the 1890s the Penney brothers lived there; after them Joe Santos, a native of Guam with a Pomo wife, farmed the island. An avid fisherman, Santos would travel by wagon to Monte Rio and Guerneville to sell fresh vegetables and fish wrapped in seaweed, tooting his horn to attract customers. In 1975 the island became part of the state park. (George Titus photo, courtesy of the Sonoma County Historical Society.)

Jenner Jetty was a handy platform for fishing, but its builders had more grandiose plans. Charles Nelson's Russian River Development Co. wanted to keep the River mouth open so his barges could dredge there for sand and gravel. Work started in May 1929 and continued seasonally for several years, with the sea undoing all the work each winter. Nelson was killed in an accident on the site in 1932. Today remnants of the jetty are often buried by sand; hikers can sometimes see the rusted rails of the track that brought loads of stone from Goat Rock to the construction site. (Courtesy of John Schubert.)

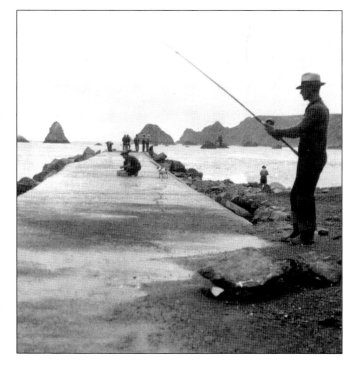

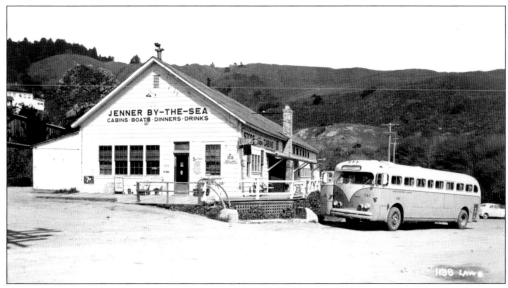

The town of Jenner grew as workers settled around the mill; in 1904 Jenner got its own postmaster (until then, residents collected their mail in Duncans Mills). When the mill closed in 1914, workers' cottages became resort cabins. The Mecum family bought Jenner-by-the-Sea resort in 1946. The next year, Cecil Mecum Jr. built the boathouse across the road. There he established the Jenner Boat Co. in cooperation with David Easdale, whose canoe business in Guernewood Park had been destroyed by fire. The boathouse was a real estate office c. 1970, when American Leisure Lands tried (and failed) to get permits for an 8,000-acre subdivision. The boathouse now houses the Jenner Visitor Center. (Courtesy of John Schubert.)

The Jenner-by-the-Sea resort burned down in 1952 and was rebuilt (it's the light building in the center). The building on the right is the gas station, also rebuilt since this photo. The white building at left, halfway up the hill, is the Jenner School. (Courtesy of the Sonoma County Museum.)

Four

STABLES AND STOREFRONTS

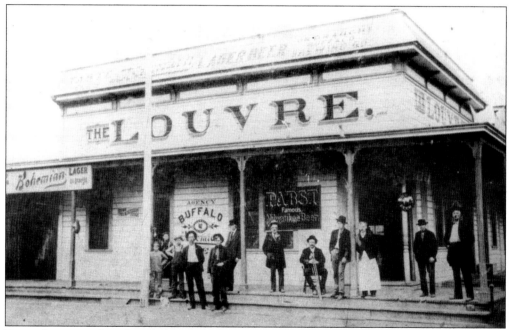

From the start of settlers' habitation, lumber mills were the first industries. Ranchers and entrepreneurs followed the timbermen, and stores opened to offer services and goods like tools and groceries. As recreation became an industry of its own, more businesses appeared: photographers, restaurants, and inns. One of Guerneville's quintessential watering holes was the Louvre Saloon, on the northwest corner of Railroad and Cinnabar (now Main and Armstrong Woods Roads). Saloons were popular gathering places every day of the week, despite Sunday Closing Laws forbidding the sale of liquor. One Louvre regular was owner Cap Wendt's monkey (halfway up the last post on the left), who liked to steal women's hats as they passed by. Cap himself is on the far right. (Courtesy of John Schubert.)

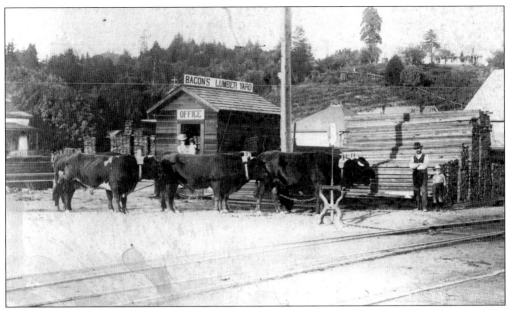

Ranchers and townsfolk fixing to build a new house, fence, or barn could get milled lumber from Bacon's lumberyard in Guerneville, c. 1890s. Occasionally the entire town would burn down, and the need for lumber would temporarily soar until the town was rebuilt. The white house on the hill at upper right is the French house. (Courtesy of the Sonoma County Museum.)

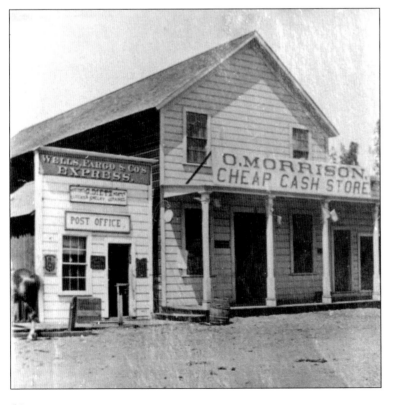

O. Morrison's Cheap Cash Store in Guerneville dwarfs the Wells-Fargo Express Office next door, which also housed the post office as well as Gerhard Dietz' jewelry store and watch repair. The date is sometime before March 1883, when a fire destroyed the store. (Courtesy of the Sonoma County Museum.)

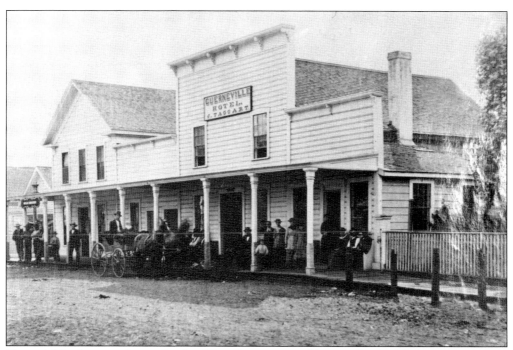

Taggart's Hotel was on the south side of First Street, pictured here in Guerneville, August 22, 1882. Owner John Taggart was one of Guerneville's early entrepreneurs. (Courtesy of John Schubert.)

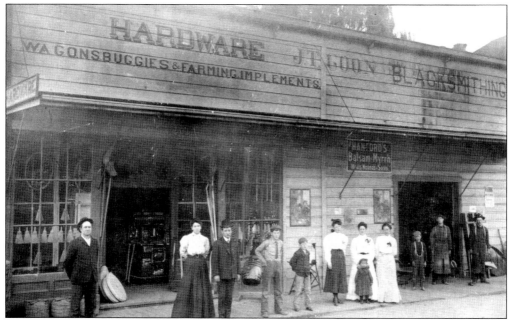

John Coon (far left) stands in front of his hardware store next to the blacksmith shop on Cinnabar Avenue in Guerneville, c. 1904. Within a few years, many blacksmith shops would also start catering to a new invention, the motorcar, offering repairs to both cars and wagons. (Courtesy of John Schubert.)

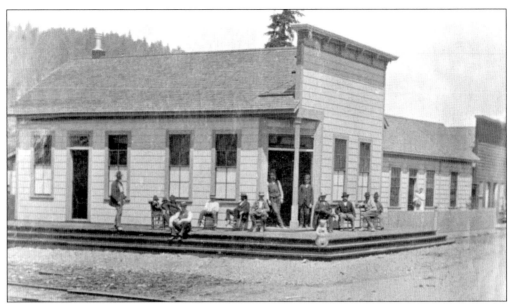

Patrons lounge on the steps of Joost and Starrett's Saloon, June 1882. The view is northwest; note the tracks in the lower left. Today this is the corner of Main and Armstrong Woods Roads. The building above burned down in 1889; its successor was demolished, along with most of the town, in the August 1894 fire. The saloon built in its place was called the Louvre. Situated at a main crossroads, this corner could be a lively place. In September 1903, owner Joost was sitting on the porch with Deputy A.J. Mackinnon, who had come to town to arrest an outlaw. His quarry, Anderson Garrod, suddenly appeared, shot Mackinnon dead, and ran off down the tracks. (Courtesy of the Sonoma County Museum.)

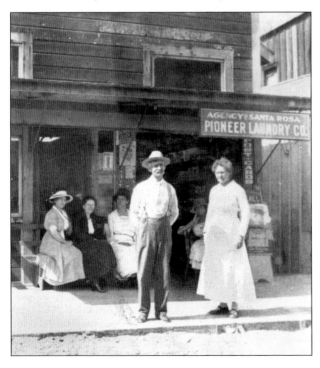

Guerneville's Pioneer Laundry also sold postcards and dress patterns. (Courtesy of Darlene Speer.)

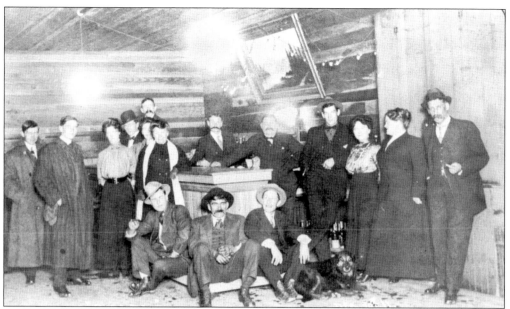

Photographer J.B. Rhea used a flashlight to capture this photo of revelers at the first dance at Carr's in Monte Rio, December 30, 1911. (Courtesy of the Sonoma County Historical Society.)

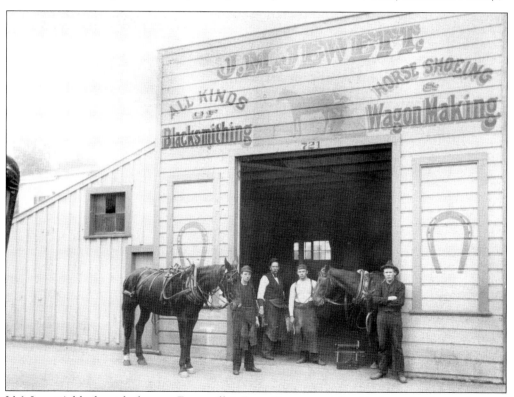

J.M. Jewett's blacksmith shop on Forestville's Front Street specialized in horseshoeing and wagon making. Most towns had a blacksmith shop; by 1910 many of them had diversified, catering to automobiles as well as to horses and wagons. (Courtesy of the Forestville Historical Society.)

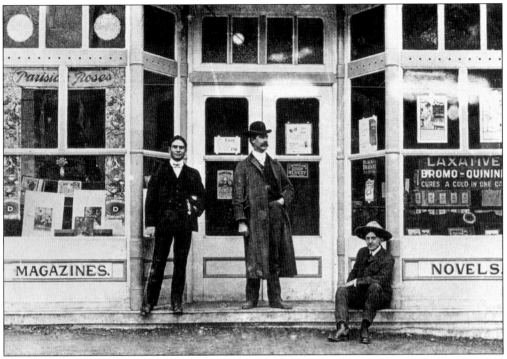

Three men pose in front of the Jewett drug store in Forestville—the date is 1905 or earlier. On the left is proprietor John Egbert "Bert" Jewett. In the center, wearing a long coat, is Dr. A.E. Byron, who sold Jewett the building. (Courtesy of the Forestville Historical Society.)

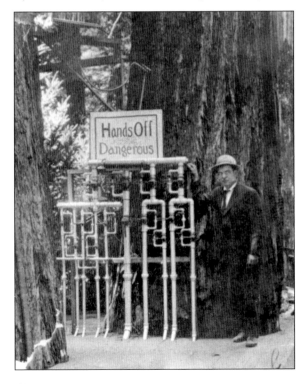

Someone has to keep the pipes in working order. Adolph Noethig of Monte Rio, shown here c. 1910, was the plumber for Bohemian Grove. San Francisco's Bohemian Club acquired the property on the south side of the River in 1900 as a place to hold its annual two-week summer encampment and revels. (Courtesy of the Monte Rio Historical Society.)

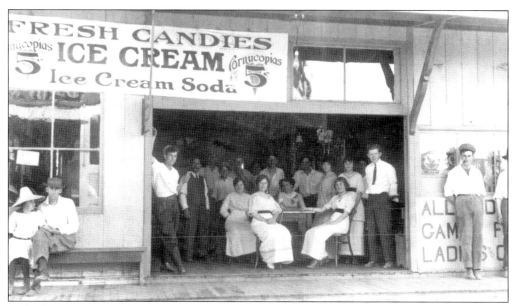

Maloof's ice cream and pool parlor, c. 1915, was a good place to cool off on hot summer days. Owners Abe and Nazara Maloof, immigrants from Turkey, ran the business with their four children, Fred, Milton, Rose, and Margaret. They sold it just after World War I and moved to Santa Rosa. (Courtesy of John Schubert.)

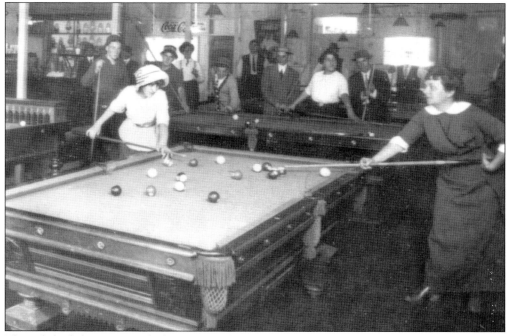

The gals had their turn with the cues inside Maloof's. (Courtesy of John Schubert.)

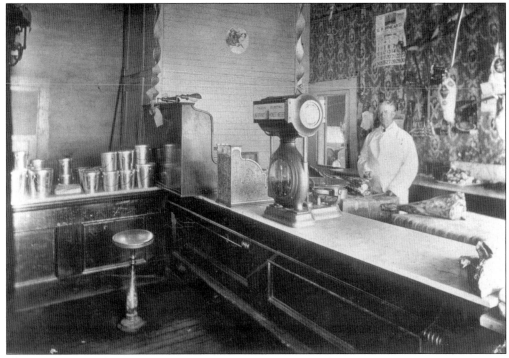

William L. Clark worked behind the counter of his Forestville meat market, September 1922. Clark started the market in 1894. (Courtesy of the Forestville Historical Society.)

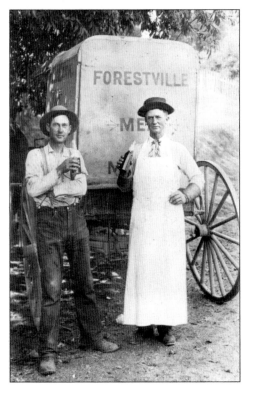

Besides running his shop in town, butcher William Clark (on the right in white apron) also made the rounds with his meat wagon, stopping at hop-pickers' camps and nearby communities like Trenton. (Courtesy of the Forestville Historical Society.)

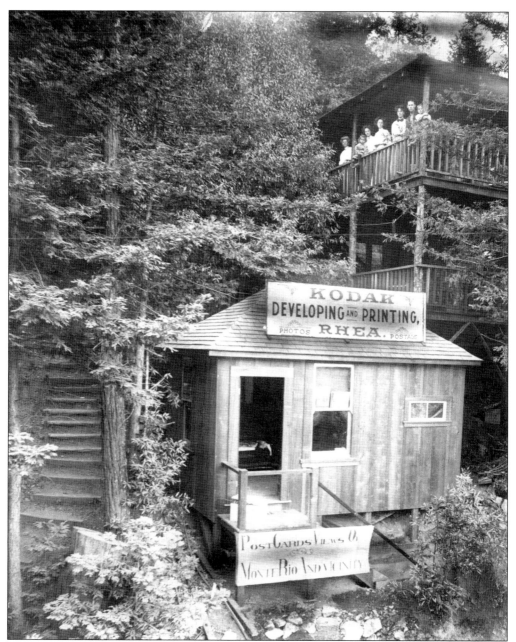

J.B. Rhea shot this photo of his own Monte Rio studio, where he offered photo developing and printing for tourists, c. 1912. Note the people on the veranda of a guesthouse at upper right. Rhea took photos of vacationers and made customized postcards for them. Many of the images we now have of people boating and sunbathing at the River early in the century are Rhea photos. Some businessmen, like Guerneville druggist Newton Lark and his uncle Fred Warne, also did photography as a sideline. Lark was a busy man—he also served as Guerneville's fire chief in the late 1910s. (Courtesy of the Monte Rio Historical Society.)

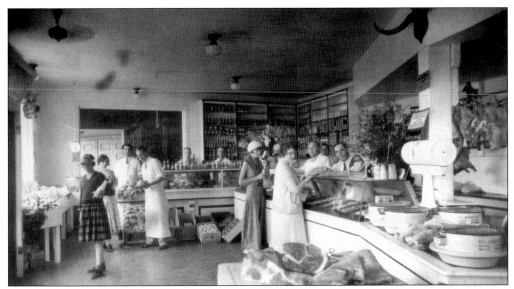

Customers flocked to the meat market on Railroad (now Main Street), c. 1928. The market belonged to Jack Starrett, who's standing in front of the counter wearing a white apron. The woman in white at the center of the photo is Norma Keaton; just to her right is Ed Smith. The shop was next to the Grove Theatre, where Starrett's sister, Alta Luttrell, sold tickets. In back of the market was the town telephone switchboard, run by another sister, Mae Starrett McLane. The market and theatre were built on the site of the first railway depot, which was relocated in 1912. (Courtesy of John Schubert.)

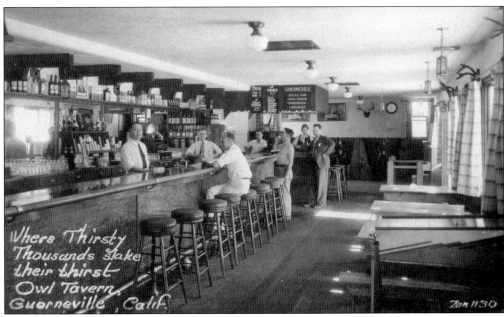

Guerneville's Owl Tavern on Main Street, where the liquor store is now, was a spot where, as the postcard says, "Thirsty Thousands slake their thirst." (Courtesy of John Schubert.)

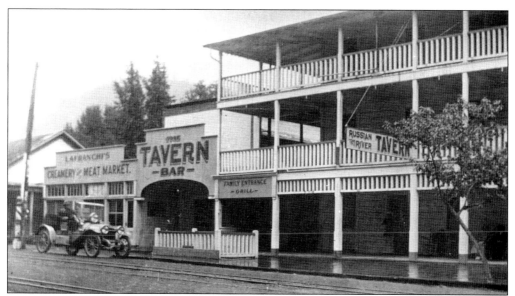

LaFranchi's Creamery (on the left) was next to the tavern and hotel in downtown Monte Rio, c. 1915. (Courtesy of the Monte Rio Historical Society.)

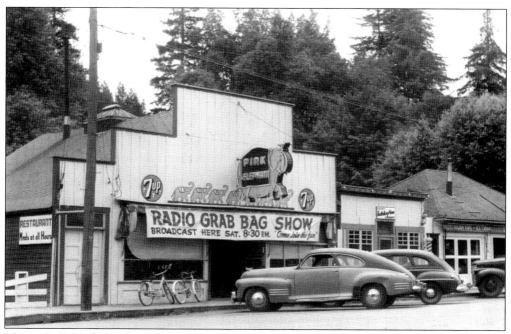

Monte Rio's Pink Elephant, c. 1951, began as a grocery and evolved into a bar and cafe after the repeal of prohibition. During the flood of 1940, patrons rowed their boats through the front door and demanded one last round before evacuating. *San Francisco Chronicle* columnist Charles McCabe, a great fan of the Pink, wrote, "When they ask you if you want a glass instead of insisting that you use one, you are in the country of free men." The Haas family bought it in the 1990s, and its neon elephant remains one of Monte Rio's enduring landmarks. To the right was a laundry and ice cream parlor. (Courtesy of John Schubert.)

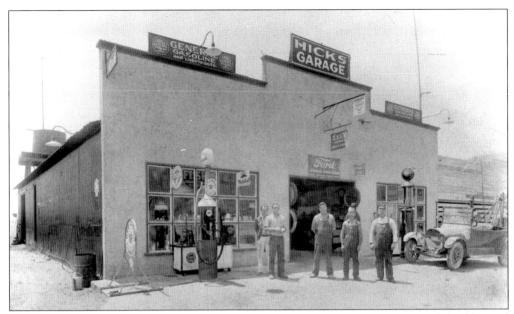

A.L. Hicks' Garage in Forestville was on the site of the Barnum building, which had housed the Rochdale Store. The building, on the west side of Front Street at the top of the hill, is now the Forestville Club. (Courtesy of the Forestville Historical Society.)

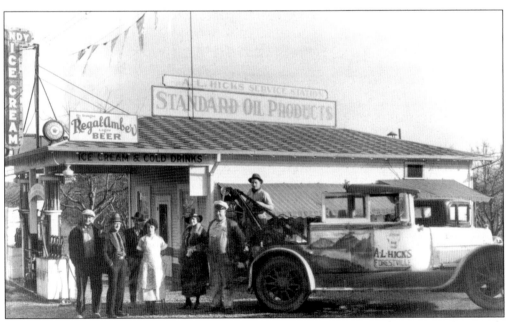

Hicks' ice cream was next to Hicks' garage (across the street from today's Carr's Drive-in). Archie Hicks is the big guy in a white cap just left of the tow truck; Mrs. Hicks sold ice cream inside. (Courtesy of the Forestville Historical Society.)

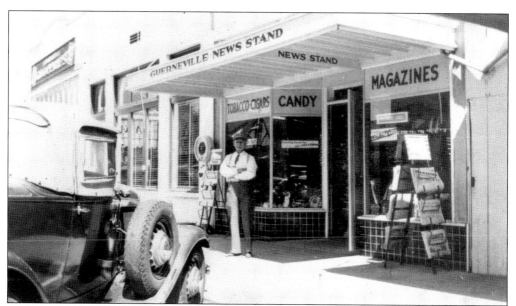

The Guerneville News Stand carried the *Guerneville Times*, whose editor, Andy Smith, had been a pressman for the *San Francisco Call*. Earlier papers in the town's history were the *Guerneville Blade* (started in 1890), the *X-Ray* (1897–1901), and the *Russian River Advertiser*, which started in 1901 and merged with the *Times* after 1913. The *Times* folded in 1966. Later newspapers included the *Russian River News*, founded in 1969, and a counter-culture paper, *The Stump*, 1972–1981. (Courtesy of John Schubert.)

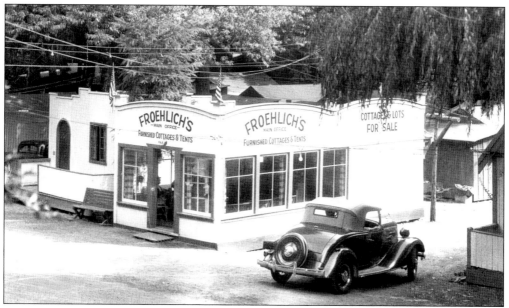

Al Froehlich came to the River in 1912 to work as a barber and eventually bought 50 tent cabins and 10 furnished bungalows in Rio Nido, which he rented to vacationers. In the late 1930s his son Kenneth (that's his '34 Whippet parked out front) started a real estate business handling the sale of cabins and resorts. Lots in the canyons were only $50; a ready-made cabin (complete with an icebox and a canoe) cost $800. (Courtesy of John Schubert.)

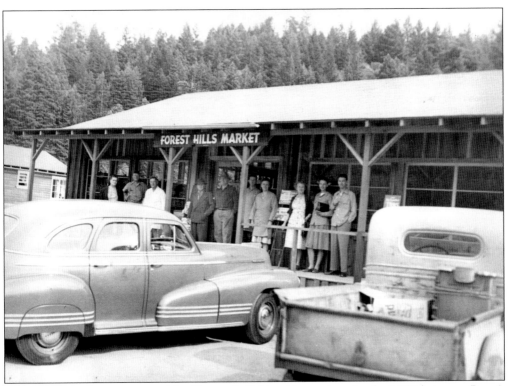

Forest Hills market, just east of the Hacienda Bridge (shown here in the 1950s), is now Berry's Market. (Courtesy of the Sonoma County Museum.)

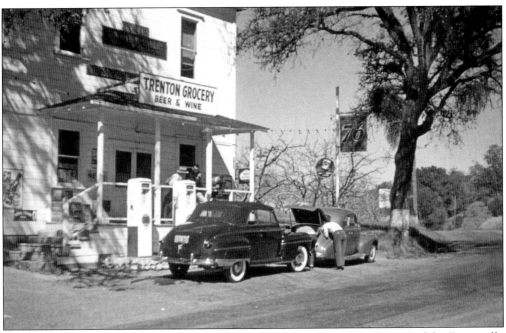

Trenton's grocery and gas station were just off River Road, *c.* 1940s. (Courtesy of the Forestville Historical Society.)

Five

WORKING THE LAND

King's Ranch north of Cazadero, with its farmhouse and outbuildings, is typical of homesteader spreads of the 19th century. Immigrants established ranches in the sunny terrain above the redwoods in the mid-1800s. As the redwoods were felled, agriculture also took hold in the valleys. (Courtesy of the Sonoma County Historical Society.)

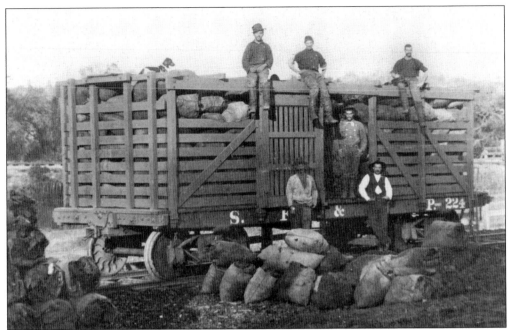

Workers pause after loading bags of charcoal onto a San Francisco and Northern Pacific rail car near Forestville, c. 1896. Locals made mounds of wood cut from tanbark oak—a tree which grows readily in the company of redwoods—and fired them to produce charcoal. (Courtesy of the Sonoma County Museum.)

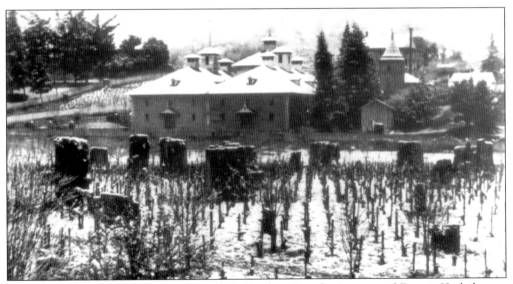

A rare snowfall hit Korbel vineyards in 1890. Brothers Joseph, Anton, and Francis Korbel came from Bohemia in 1860 and bought 6,000 acres of redwoods east of Guerneville. Their mill processed wood for boxes for their San Francisco cigar business. The Korbels were instrumental in getting the broad gauge railway line built west from Fulton. When it opened in May 1876, Korbel was the terminus (though not for long—the extension to Guerneville opened in March 1877). The restored Korbel Depot is now a museum on the grounds of the winery. (Courtesy of the Sonoma County Museum.)

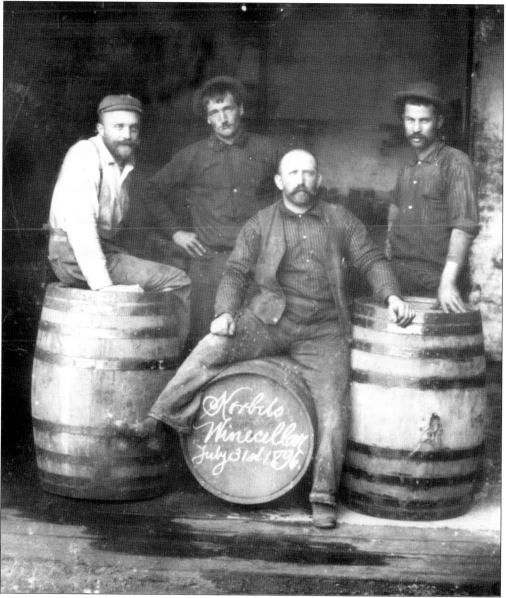

The Korbel champagne crew was, left to right: Charles Zedtwitz, unidentified, champagne master Frank Hasek (straddling the barrel), and Luigi Bortoli. This picture was taken on July 31, 1896. Korbel's timber was depleted by 1880; the brothers then used the logged acreage for grapes, becoming U.S. pioneers of the *methode champenoise*—the technique of making champagne in the bottle. The first champagne shipped in 1882. They also set up a printing plant to produce their own colorful wine labels as well as a political magazine, *The Wasp*. In 1954 the Korbels' descendants sold the winery to the Hecks, who learned the wine trade in Alsace. Korbel champagne has since become the preferred beverage for Presidential inaugurations. (Photo by Milo J. Pesak, courtesy of the Korbel Winery.)

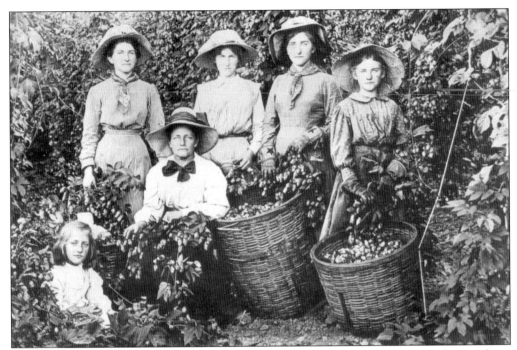

Every August whole families camped in the fields picking hops, an essential ingredient in beer. Hops grew along the River and its tributaries near Forestville. After the redwoods were cut, hops were also planted at the Guerne property near Lone Mountain. Here, a family picks hops at Cecil von Grafen ranch on Westside Road, c. 1912. Pictured left to right is the Meredith family: Mildred, Virginia (the mother of the other women), Helen, Blanche, and Gladys. The girl in front is Zelma Meredith. (Courtesy of Lorraine Owen.)

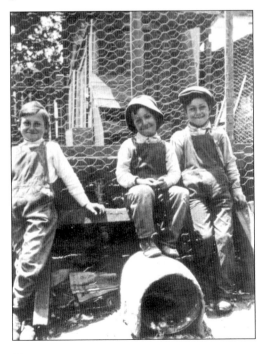

Three Guerneville boys, like other rural kids, helped with farm duties when not in school. (Courtesy of Darlene Speer.)

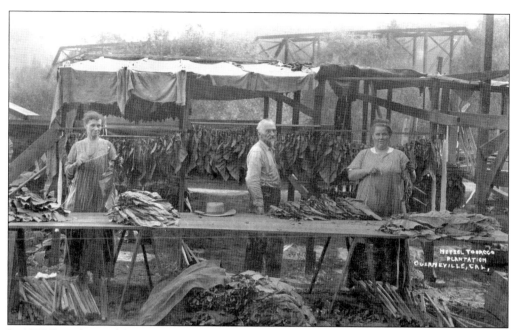

In 1877 David Hetzel (center) planted tobacco on Mount Jackson, then moved into Guerneville and planted a few acres along the river, eventually specializing in Havana-style tobacco for cigars. The women at the curing shed are Nellie Justis (left) and Nell Morrow. Note the 1885 Guerneville Bridge in the background. (Courtesy of Darlene Speer.)

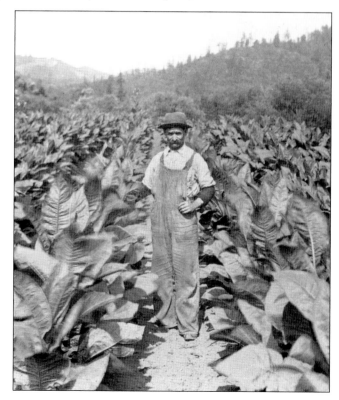

Fred Ewing, one of Hetzel's workers, is nearly dwarfed by the thriving tobacco plants. Hetzel shipped his cigars to San Francisco and in the 1890s also sold them in his tobacco store in Guerneville's Oddfellows' building. By the early 1900s, his tobacco was winning awards at state and national expositions. Hetzel had come to America from Germany as a boy. He served in the Civil War in the New York 74th Infantry and in later years proudly marched in Guerneville's Memorial Day parades wearing his black campaign hat. (Courtesy of Darlene Speer.)

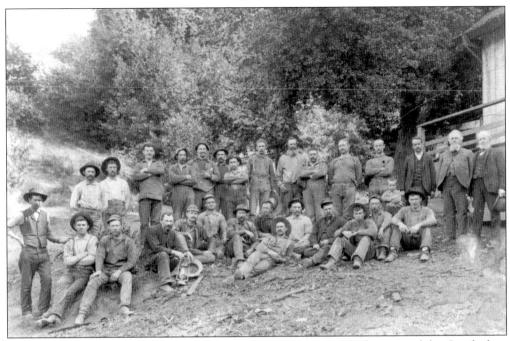

Mine owner Richard E. Lewis (second from the right) posed with the crew of the Quicksilver mine, c. 1890. Lewis came to Guerneville in the early 1860s and in 1875 filed a claim for the Great Eastern Quicksilver Mine, which yielded cinnabar. Mercury (quicksilver), which was used to extract gold and silver from ore, comes from cinnabar. (Courtesy of John Schubert.)

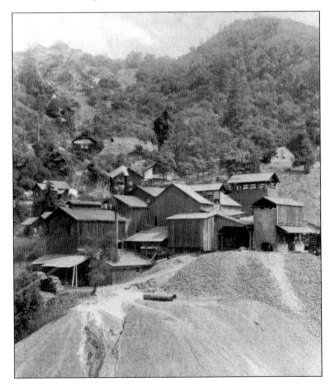

The town of Mercury, on Sweetwater Springs Road, sprang up near the Great Eastern Quicksilver Mine (left), shown here c. 1890. Mercury had 57 families, a post office, a town hall, and a school. Mine owners closed the one saloon, as it interfered with production. Three miners—Robert Gorsky, 16; Charles Hanson, 37; and Fred Miller—died in the mineshaft during the 1906 quake. Following the quake, the mine remained closed until 1915; afterward it operated off and on as the price fluctuated. (Courtesy of John Schubert.)

Six

LAZY DAYS AND
MUSICAL NIGHTS

John A. Barham was an attorney and, from 1895 to 1901, the congressional representative for the first district. He also loved to go fishing on the Russian River. Until the mid-1950s, the lower Russian River was a paradise for fishermen, with 50,000 to 100,000 salmon and steelhead crowding the water to get upstream. Fishermen came to stay at the resorts, supporting businessmen like Guerneville's Grant King, who owned a tackle shop on Main Street. Flood control projects—especially the 1958 Coyote Dam that formed Lake Mendocino—disrupted the fish runs, although fishing is still a popular River activity. (Frank Kuykendall photo, courtesy of the Sonoma County Museum.)

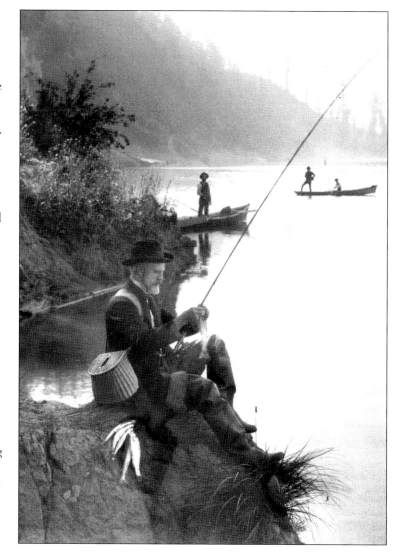

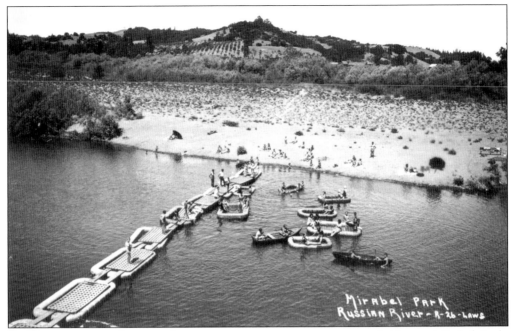

Local swimmers used war-surplus pontoons to construct a summer bridge at Mirabel Park, pictured here in the late 1940s. They also made rafts from the converted pontoons, used during World War II for making impromptu bridges. (Courtesy of the Forestville Historical Society.)

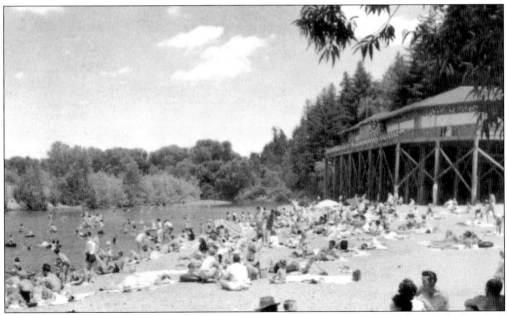

Crowds throng the beach near the Mirabel dance hall, c. 1950s. Mirabel and the nearby Rio Dell Resort offered dancing and roller-skating. (Courtesy of the Forestville Historical Society.)

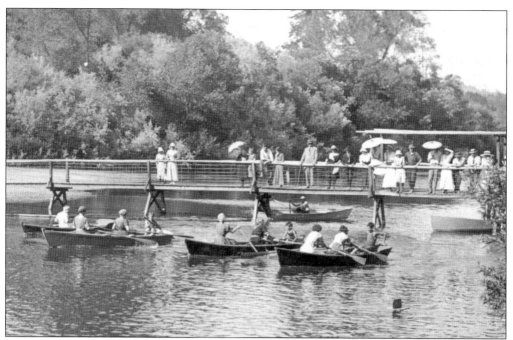

Ladies with parasols watch from the bridge while their friends pull on the oars during the Ladies Boat Races at Summerhome Park. Summerhome is upstream from Hilton, a popular campground owned in the 1950s by "Jinks" Konkel, a cousin of the author. (Courtesy of John Schubert.)

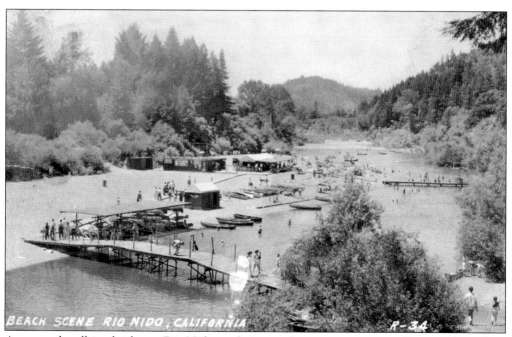

BEACH SCENE RIO NIDO, CALIFORNIA R-34

A seasonal walking bridge at Rio Nido made it easy for vacationers to walk across from their cabins to the wide sandy beach on the south side of the river, 1946. (Courtesy of the Sonoma County Museum.)

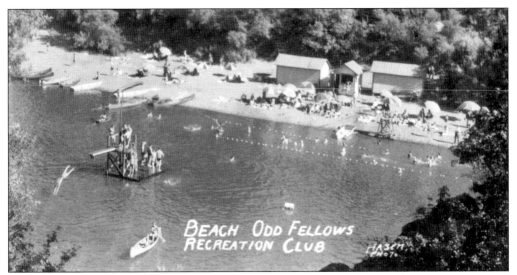

Vacationers enjoyed the beach at Oddfellows Park, 1935. Note the person diving from a mid-river board at lower left. Oddfellows Park was a private development whose members were Oddfellows or Rebekahs. Beginning in 1928, they bought lots for $150 to $200. Members could also bring guests, and in summer as many as 200 campers and residents jammed the beach. (Courtesy of John Schubert.)

Oddfellows Park, across the River from Korbel, boasted its own store (seen here in 1942). Wives and kids from San Francisco would come up for the summer, while husbands arrived by train (and later by car) for the weekend. The butcher drove in to sell meat from the back of his truck, and the Yoo Hoo Ice man would unload a block of ice at your cabin door if you stuck a "Yoo Hoo" sign in the window. Evening entertainment included bingo, with a character known as Shake-em-up Gladys shaking out the numbers. Similar developments included Summerhome Park, c. 1905, and the American Legion Park, c. 1920, just east of Hacienda, with World War I-inspired street names (some of them misspelled) like Champs de Elysses. (Courtesy of John Schubert.)

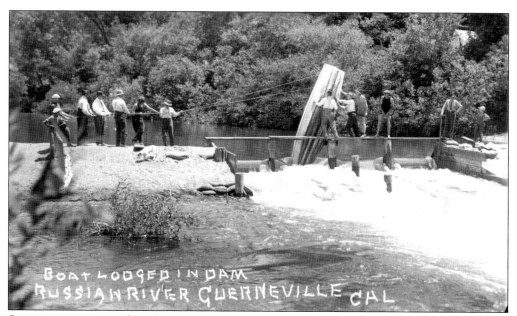

Sometimes canoes and rowboats got hung up in the summer dams that were built to create swimming holes. Here a gang of helpers tugs on the rope to free a boat wedged in a dam near Guerneville. (Courtesy of the Sonoma County Museum.)

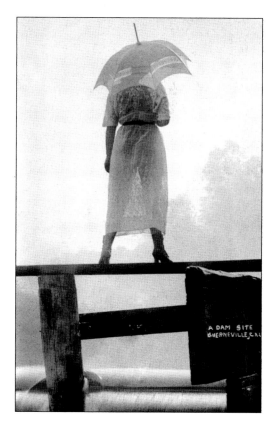

One visitor posed with her umbrella atop a summer dam near Guerneville, c. 1915. The writing at lower right says, "a dam site." (Courtesy of John Schubert.)

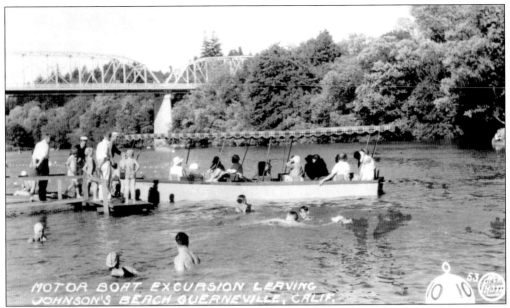

Thomas "Bid" Greene ferried people from Johnson's Beach to Rio Nido in a motor launch powered by a Model T engine, c. 1930s. Greene, who captained the boat from 1931 to the 1960s, kept a phonograph on board; the trip was usually over before passengers grew tired of his one record, appropriately titled "Cruisin' on the River." Night cruises took revelers to and from dances at Rio Nido. (Charlie Peck photo, courtesy of John Schubert.)

Clare Harris still runs the concession stand at Johnson's Beach in Guerneville, pictured here c. 1955. The first summer dams, which created the Russian River's popular swimming holes, went up in 1897. Snack bars inevitably followed. So did canoe rentals like the ones still running at Johnson's Beach and at Burke's in Forestville. Note the 1922 bridge in the background. (Courtesy of John Schubert.)

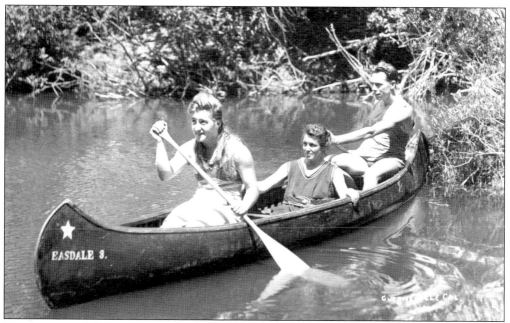

Vacationers paddle an Easdale canoe with its trademark star on the bow, 1925. John Easdale and his son David made canoes and rowboats in their Guernewood Park shop, using special molds for shaping the hulls. After a fire destroyed their workshop, David became a partner in the Jenner Boat Co. in the 1940s. (Courtesy of John Schubert.)

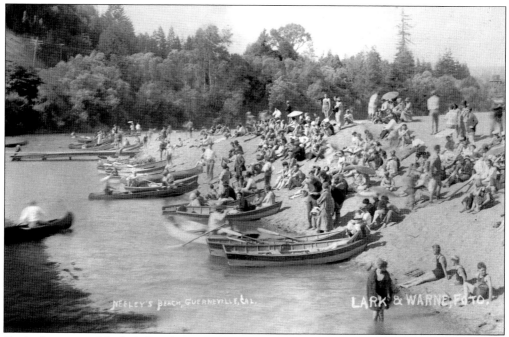

Sunbathers cover Neeley's Beach just downstream from Guerneville, *c.* 1914. Note the summer bridge in left background. The Neeley's neighborhood is on the south side of the river, west of Highway 116. (Lark and Warne photo, courtesy of Darlene Speer.)

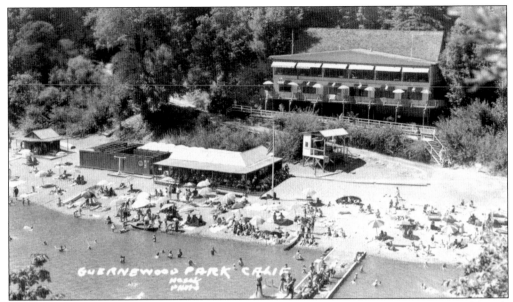

The resort at Guernewood Park was one of the largest in the area, with a hotel and beach concessions. (Courtesy of John Schubert.)

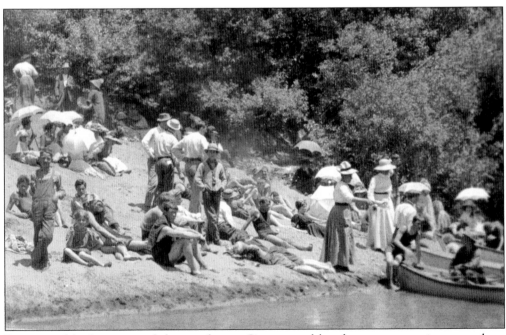

Boaters and bathers enjoyed the weather at Guernewood beach; some are toting parasols to shield them from the sun. Note the long skirts and wide-brimmed hats. This is a detail of a postcard sent by Annie Walter to Miss Emgard Vogel in San Francisco, July 29, 1911. (Courtesy of John Schubert.)

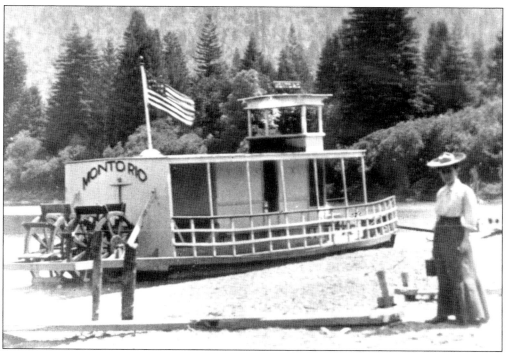

The *Monto Rio* (above) and the *Acona*, piloted by Charlie Meadows, ferried tourists from Camp Vacation to Monte Rio, *c.* 1915. Between 1902 and 1909, Camp Vacation was the terminus of the broad gauge railroad, and the ferry was the only way to continue downriver to Monte Rio. (Ed Mannion collection, courtesy of John Schubert.)

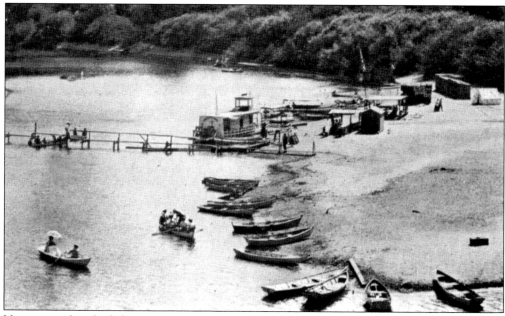

Vacationers beached their canoes near Charlie Meadows' Boat House on the south side of the River near the walking bridge. (Courtesy of John Schubert.)

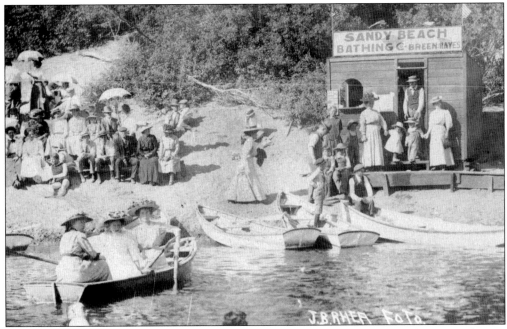

The three women in the boat at lower left commissioned local photographer J.B. Rhea to take their photo at Monte Rio's Sandy Beach on August 7, 1909. (J.B. Rhea photo, courtesy of John Schubert.)

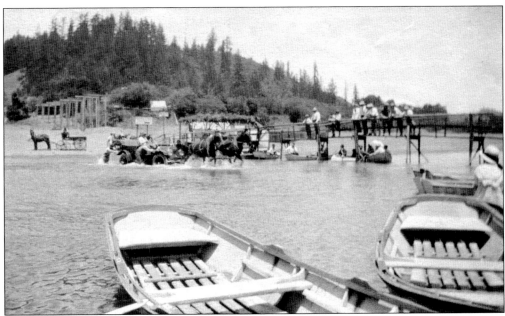

A team of horses helps an automobile get across the River on June 29, 1913. The spectacle drew a number of on-lookers, who watch from nearby boats and from the walking bridge. (Courtesy of John Schubert.)

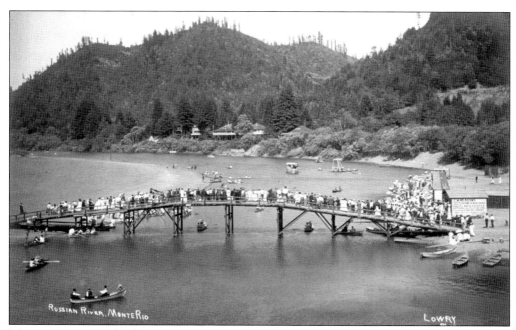

Monte Rio summer bridge, *c.* 1915, ended at the Meadows boathouse, on the south side of the River. The photo is taken from the old Monte Rio traffic bridge, which was replaced by the current bridge in 1934. (Lowry photo, courtesy of John Schubert.)

Three ladies pose on the bridge from town to Sandy Beach. Once the broad gauge trains came to Monte Rio from Guerneville in 1909, tourists could take either route to Monte Rio. San Franciscans could also buy a $2.50 ticket for a "Triangle Trip" from the Sausalito ferry terminal, arriving at the River by narrow gauge, and coming home by the standard gauge (or vice versa). (Courtesy of the Monte Rio Historical Society.)

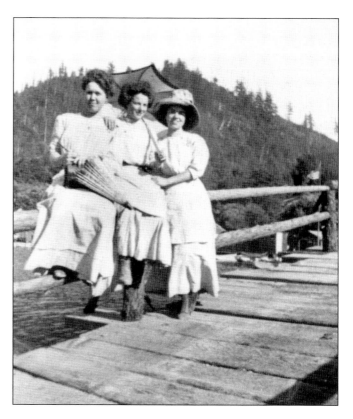

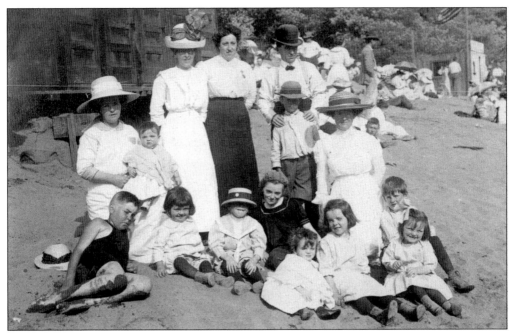

Regulars at Monte Rio's Sandy Beach, *c.* 1910, included: (back row) Susie Hayes with baby, Mollie Breen, Mrs. McGrath, her brother Mr. McGrath with his hands on the shoulders of his son, and Mrs. Higgins; (front row) Weston Hayes, Dorothy (?), Virgil Breen, Mac Higgins, unidentified, Jimmy Higgins, and Florence Higgins. (Courtesy of the Monte Rio Historical Society.)

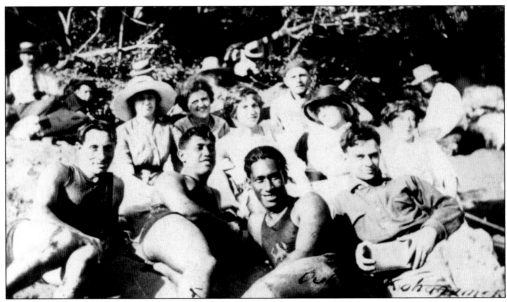

Monte Rio beach goers cluster around a famous visitor, Duke Kahanamoku (front row, second from right), star of four Olympics and an early proponent of surfing, *c.* 1920s. The third man from right is fellow Hawaiian Robert Kaawa. (Courtesy of the Monte Rio Historical Society.)

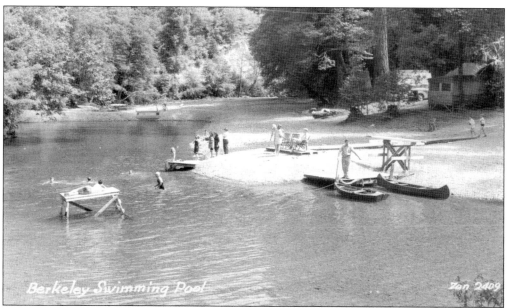

Berkeley swimming hole on Austin Creek was downstream from Cazadero, c. 1955. Owned by the City of Berkeley, the Berkeley Music Camp gave summer scholarships to city kids to study jazz, classical, and later electronic music under the redwoods. Campers took turns providing freestyle reveille each morning. The camp suffered a close call in the 1978 Creighton Ridge fire; eventually other civic organizations bought the camp and it became the Cazadero Music Camp. (Courtesy of the Sonoma County Museum.)

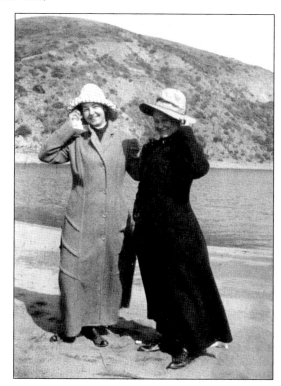

Ladies buttoned up their long coats and held onto their hats in a strong breeze near Jenner. (Courtesy of Darlene Speer.)

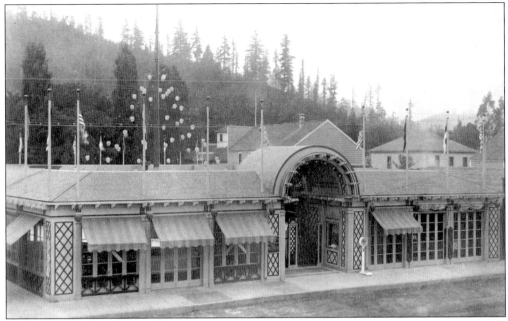

When the sun went down, people hung up their bathing suits and changed into dancing togs. After dark, vacationers went to the Rio Nido Lodge, the Grove (above) in Guerneville, or other dance halls. In this 1920s photo, the Grove was still an open-air pavilion; it acquired a roof in 1930. (Courtesy of Darlene Speer.)

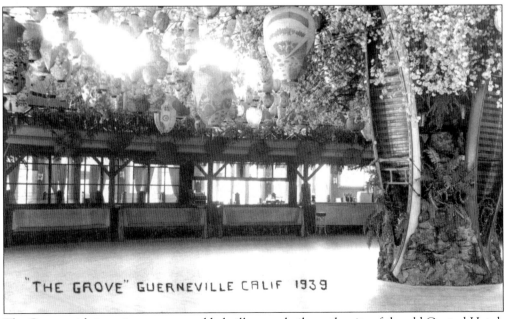

"THE GROVE" GUERNEVILLE CALIF 1939

The Grove, with its unique canoe-studded pillar, was built on the site of the old Central Hotel. This is the interior in 1939. Many clubs had regular bands; Ray Tellier and his 16-piece band had a regular gig at the Grove from 1929 to 1940. (Courtesy of John Schubert.)

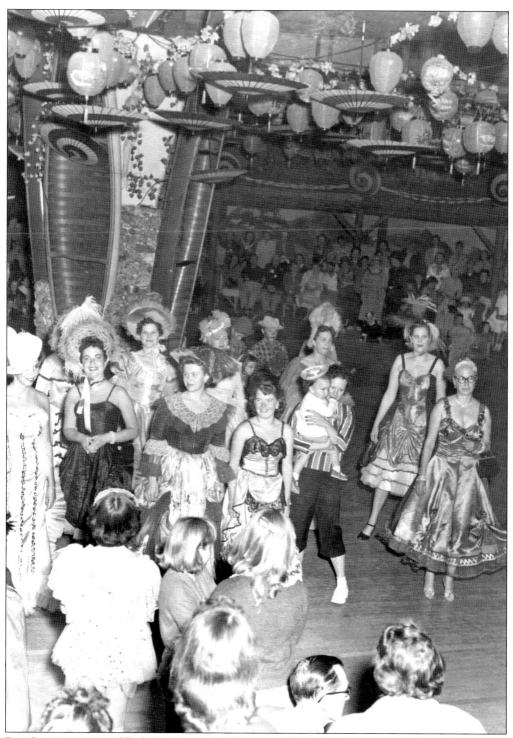

Revelers in costume filled the Grove Pavilion, one of the River's most popular nightspots, in this 1950s shot. On October 19, 1963, a fire destroyed the Grove and several buildings around it, including Ferenz Sporting Goods and Gori's Tavern. (Courtesy of John Schubert.)

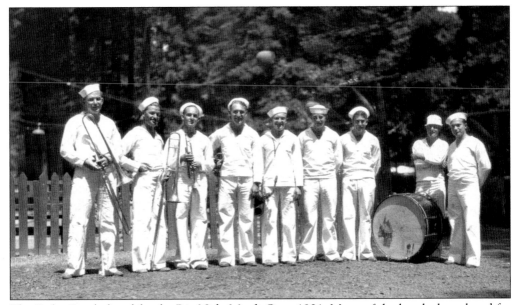

The Sailor Band played for the Rio Nido Mardi Gras, 1931. Many of the bands that played for River dance halls had themes, like Harry Owens and His Royal Hawaiians, or Horace Heidt and his Collegians, a group from Cal Berkeley. Resorts at Mirabel and elsewhere also offered bowling and roller-skating. (Courtesy of John Schubert.)

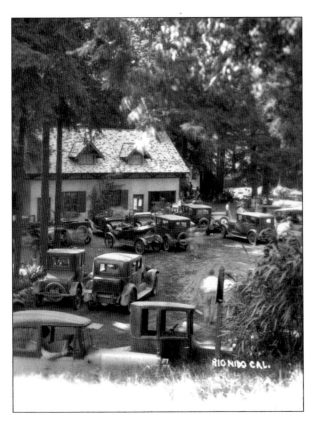

In 1935, Harry Harris, owner of Rio Nido Lodge (left) contracted with the Music Corporation of America to put the Lodge on a circuit that booked the nationally-famous Big Bands like those of Harry James, Glenn Miller, Phil Harris, and Woody Herman. Once the Golden Gate Bridge opened in 1937, more and more tourists drove their own cars to the River on weekends for music and dancing. During summer months, there was dancing every evening, and the grounds of Rio Nido Lodge were jammed with autos. The advent of television and easier access to Tahoe undermined the River's dance halls and resorts in the '50s, and in 1953 the Harris family sold the resort. (Courtesy of John Schubert.)

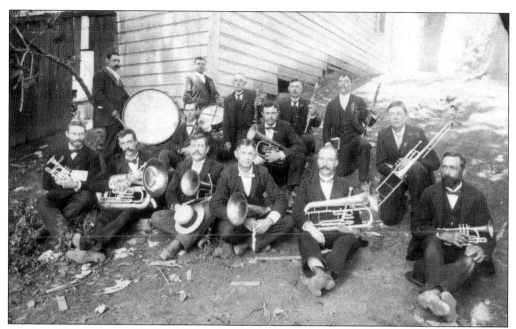

Local musicians formed the band that played on the balcony of the Grand Central Hotel (also known as Graham's), 1897. Pictured here from left to right, starting in the front, are Professor Fred Wright (who played despite having only one arm), Arthur Turner, Jim Banks, John Ungerwitter, Bert Bagley, and Ivon Clar. In the second row, far right, is John Joost, who enlisted in the Army as a band player during the Spanish-American War. (Courtesy of John Schubert.)

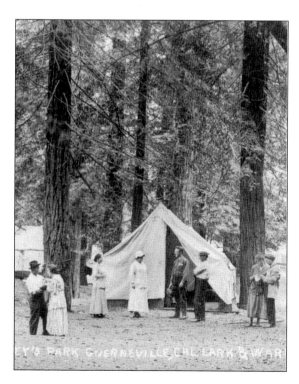

Most River tent campgrounds, like this one at Neeley's Park, 1912, provided wooden platforms and stoves along with the tents. At Neeley's and Guernewood Park, local stores delivered meat and milk directly to the campsites. By the early 1900s there were dozens of guesthouses and campgrounds from Forestville to Duncans Mills, most of them listed in Northwestern Pacific Railroad's Vacationland brochure. In an effort to boost the railroad's business, the NWP brochure listed the vacation spots and advised vacationers where to get off the train for each one. (Lark and Warne photo, courtesy of John Schubert.)

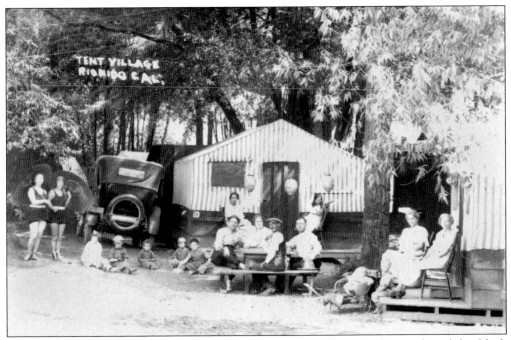

Rio Nido's tent village is a precursor to today's motel. Note the two bathing girls with big black umbrellas on the far left, near the family car. (Courtesy of John Schubert.)

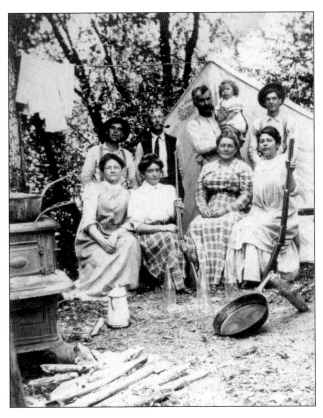

Whole families camped on the riverbank. Note the cookstove at left and wood to feed the fire at this camping spot near Guerneville. Judging from the rifles the women are holding, they may have shot their own food before gathering to make dinner. (Courtesy of John Schubert.)

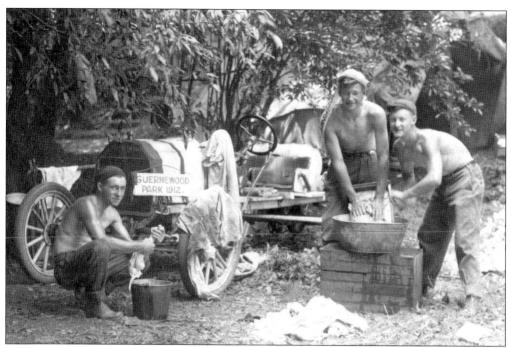

Three buddies camped next to their jalopy at Guernewood Park in July 1912, sending this postcard back to San Francisco with the message, "Dear Ella, wish you were here, you could wash our shirts. Tom." (Courtesy of John Schubert.)

Many visitors chose tents or cabins, but others stayed at hotels and lodges like the Guernewood Hotel, with its cozy common room. In the 1960s, many cottages were converted to year-round use; the area attracted counter-culture folks, many of whom moved into what were once summer cabins. In the 1970s, the River area became a magnet for gay and lesbian residents, who opened businesses and resorts and helped revive the River's flagging economy. Today the lower River has about 10,000 inhabitants. (Courtesy of John Schubert.)

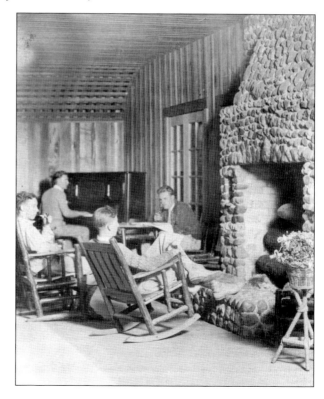

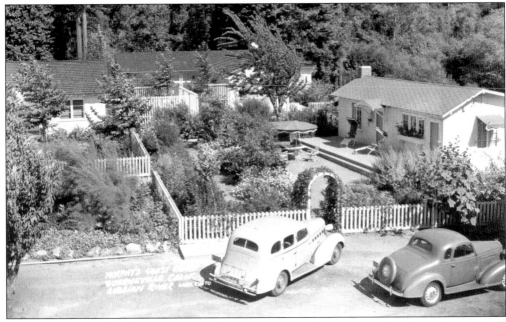

Murphy's Resort offered tents, chalet cabins, quiet grounds, and sandy beaches. Owner Dosia Murphy, who purchased the property between Livreau and Fife Creeks in 1905, served up mounds of food during busy summer months. When the railroad pulled out in 1935, summer visitors continued to come by car. Dosia ran Murphy's Ranch until she died at age 99. Her heirs sold it to Peter Pender, who renamed it Fife's; it became the River's biggest gay resort. (Lark photo, courtesy of John Schubert.)

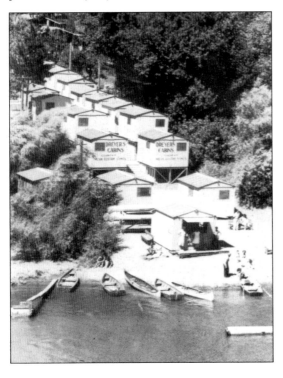

Dreyer's Resort, downstream from Johnson's Beach, offered cabins, canoes, and easy access to the beach. It later became Fire Mountain Lodge. (Courtesy of John Schubert.)

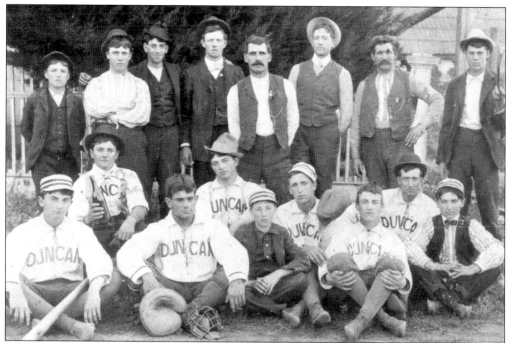

The Duncans Mills baseball roster is a catalogue of local family names. Pictured here are, left to right: (back row) Ray Roix, Homer Morrell, Ed Dedy, George Lambert, Bill Morrell, unidentified, Alfonso Franceschi, and George Lambert; (front row) Eddie LaFranchi, Otto LaFranchi, Henry LaFranchi, Johnny LaFranchi, Bill Roix, George Moore, Jim DeCarly, John Berry, and Willie LaFranchi. (Courtesy of the Sonoma County Historical Society.)

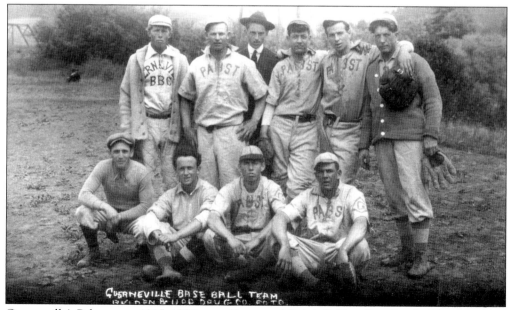

Guerneville's Pabst team, 1915–1920, was: (front row) Ralph Belden, Roy Smith, Glen Laughlin, and Beanie Wells; (back row) Elmer Tomblinson, John Shoemake, Ben Wescott, Vern Clar, Jack Starrett, and Bert Klein. Note the 1885 bridge at upper left. (Courtesy of John Schubert.)

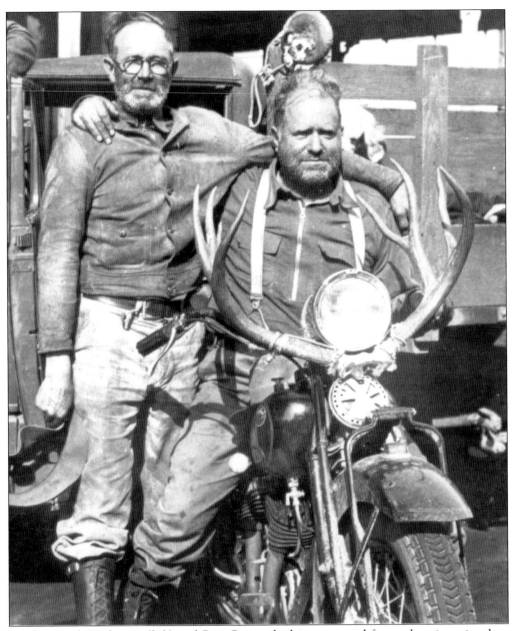

Buddies Frank Buchanan (left) and Bert Guerne had just returned from a hunting trip when they posed in front of the Louvre in Guerneville. At one time Bert was owner of the Southside Resort, at the south end of the Guerneville Bridge. (Courtesy of John Schubert.)

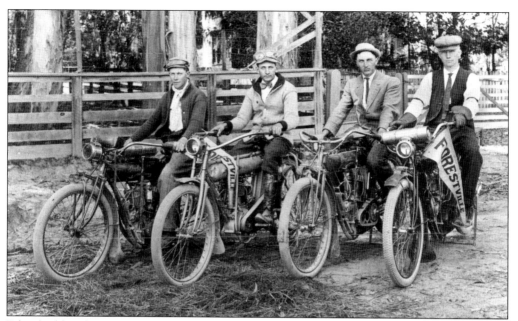

Biker buddies display their Forestville pennants. Pictured are, left to right: Milton Nicks on an Indian motorcycle, Clint Yeager, Earnest Everett Close on his Indian, and Clyde Fouts, *c.* 1900. (Courtesy of the Forestville Historical Society.)

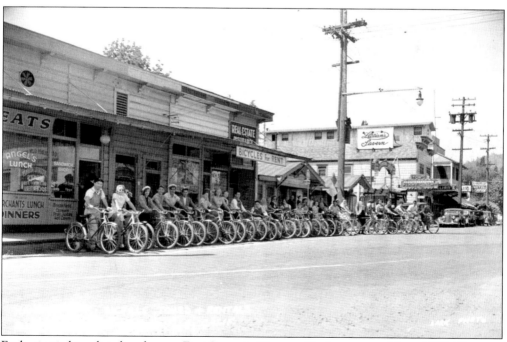

Enthusiastic bicyclists lined up on First Street in Guerneville for a group ride, *c.* 1940. The two-story building on the right is the Hotel Nicholls. (Courtesy of John Schubert.)

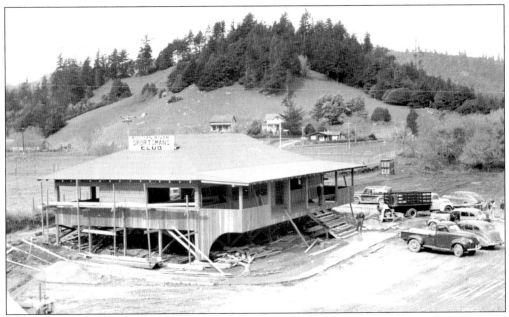

Members of the Russian River Sportsman's Club, founded in 1936, pooled their talents to build a clubhouse at Duncans Mills using lumber milled in Cazadero. The view is from the bridge. The club's 500 members lobbied for the preservation of fishing habitat and against the construction of Coyote Dam. Today the club has about 100 members. (Courtesy of John Schubert.)

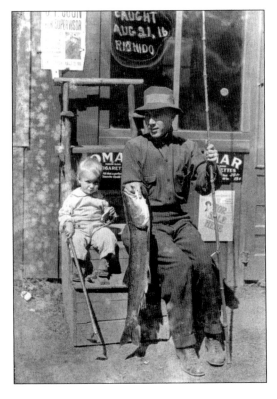

Two avid fishermen pose with their catch in Rio Nido, August 1916. Note the election flier urging voters to vote for J.T. Coon. John Coon, who ran the hardware store next to the blacksmith on Cinnabar Road in Guerneville, ran unsuccessfully for county supervisor against William King of Cazadero. For its size Cazadero had great influence in legal administration: the first judges of Redwood Township—Francis Trosper, Ernie Trosper, and Chester Rogers—were all from Cazadero. (Courtesy of John Schubert.)

Seven

THE SOCIAL WHIRL

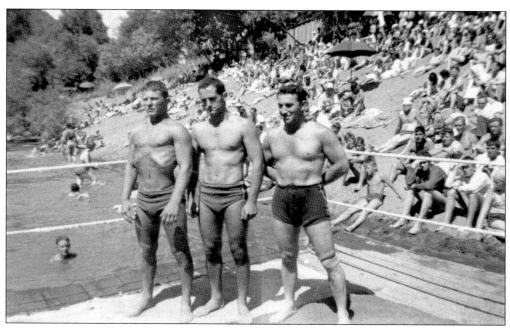

In small towns without museums, symphonies, and town councils, people organize their own entertainments—water carnivals, pageants, parades, and festivals—from the materials at hand. Most events are annual and many celebrate the start or the close of the summer season. The musclemen in this temporary riverside wrestling ring were probably part of the Monte Rio's annual water carnival. (Courtesy of the Monte Rio Historical Society.)

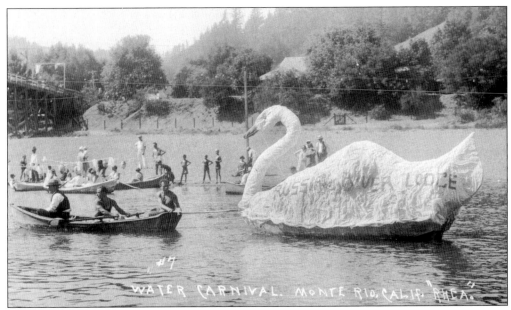

The Monte Rio Water Carnival began in 1912 so San Francisco vacationers could do justice to the Fourth of July without lighting fireworks, which might have set the surrounding woods on fire. Vacationers would watch the water parade from Big Sandy Beach or the walking bridge over the River. The Russian River Lodge sponsored the swan float. (J.B. Rhea photo, courtesy of the Sonoma County Museum.)

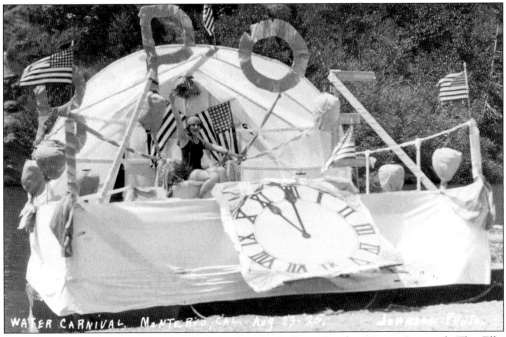

Local clubs, businesses, and individual families built floats for the Water Carnival. The Elks Club (BPOE) built this one. (Johnson photo, courtesy of the Monte Rio Historical Society.)

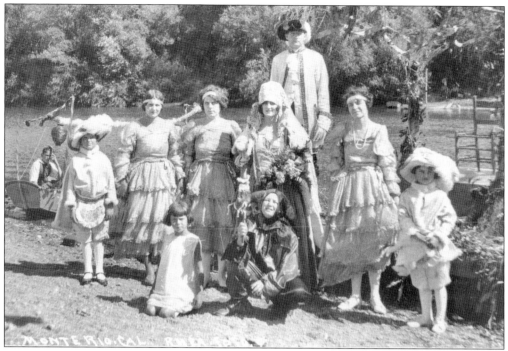

The Water Carnival Queen posed with her court, c. 1920s. Leland Ahern is standing in the rear. The others are, left to right, Georgie Guidotti, unidentified, June LaFranchi, Fern Guidotti, Queen Lorabelle King, and two unidentified persons. Leland Geisenhofer, in front, is the court jester. (Courtesy of the Monte Rio Historical Society.)

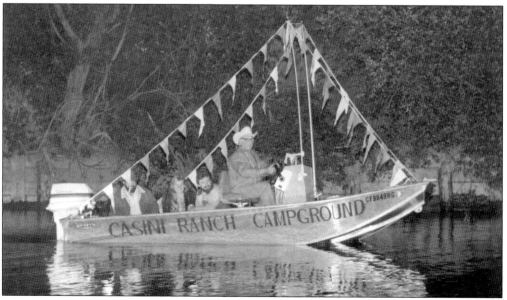

George Casini, owner of Casini Ranch Campground near Duncans Mills, steers the ranch's entry in the 1985 carnival. Also on the boat are Paul Casini, Susan Austin, and James Austin. George's grandparents, Bartolomeo and Anastasia Casini, ran the European Hotel near the Moscow Mill, where Casini's campground is now. (Courtesy of the Monte Rio Historical Society.)

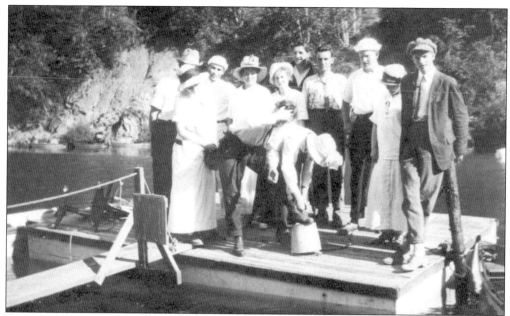

The end of the school year is always a good excuse for a celebration. This high school class held its year-end picnic on the River at Guernewood Park on June 16, 1915. (Courtesy of Ripley Wilson.)

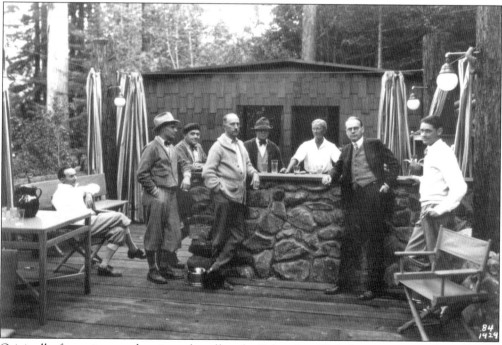

Originally for writers and artists, the all-male Bohemian Club became an enclave for the nation's power brokers. Activities at their two-week camp at Bohemian Grove, near Monte Rio, range from picnics to Lakeside Talks by movers and shakers like William F. Buckley and Caspar Weinberger. Here Kent, Ben Purrington, Mason, Dobie, Finks, Templeton Crocker, Harris, and Hook enjoy a drink at the Grove, 1929. (Courtesy of Sonoma County Library.)

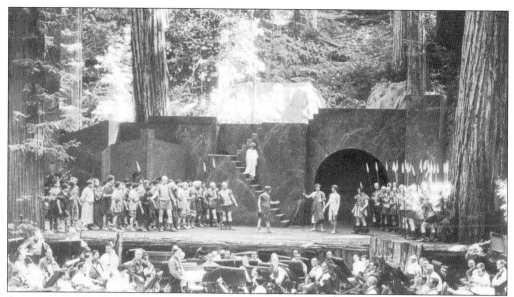

Starting in 1902, Bohemians staged an annual summer play on a grand scale that incorporated the forest setting. Club members—doctors, financiers, etc.—are expected to join the cast. The Club, founded in 1872, held summer campouts at Elim Grove from 1887 to 1891; it bought the redwood-studded Grove property in 1900. Members belong to one of 122 camps, each with its own clubhouse. Mandalay members include Gerald Ford and Henry Kissinger; George Bush Sr. is a member of Hill Billies. All Grove activities are off-limits to the general public, but the Club also performs an annual public benefit for the Monte Rio community. (Courtesy of John Schubert.)

Lowell Thomas, nationally known news and travel commentator, broadcast his show from Northwood while he was in town for the Grove's annual two-week camp. Northwood Golf course, built in 1926 as a complement to the Grove, is the world's only course with redwoods lining all nine holes. A walking bridge gave Club members easy access to the course designed by Jack Neville, a Boho member who also designed the Pebble Beach course. Celebrities who have played here over the years include Arnold Palmer, Adolph Menjou, Bing Crosby, and Bob Hope. (Courtesy of the Monte Rio Historical Society.)

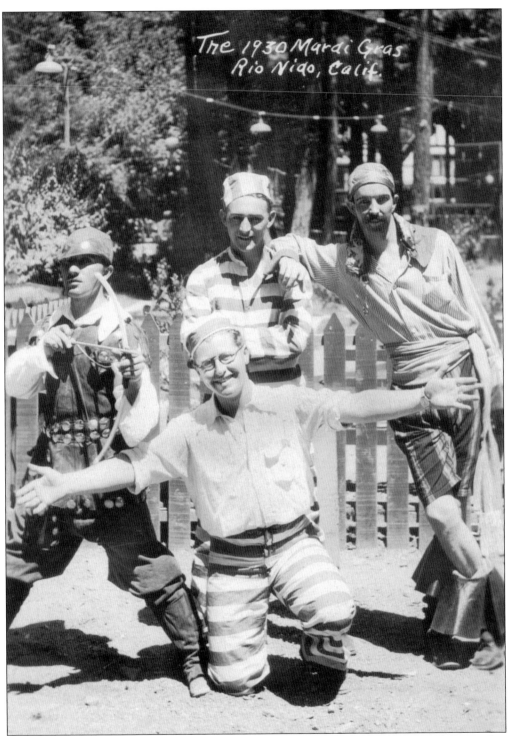

Every August the town of Rio Nido held its own summer festival—the Rio Nido Mardi Gras, a let-'er-rip event where adults dressed as kids and kids impersonated adults. For the 1930 festival, Robin Hood, a pirate, and two jailbirds hammed it up under the redwoods. (Courtesy of Ripley Wilson.)

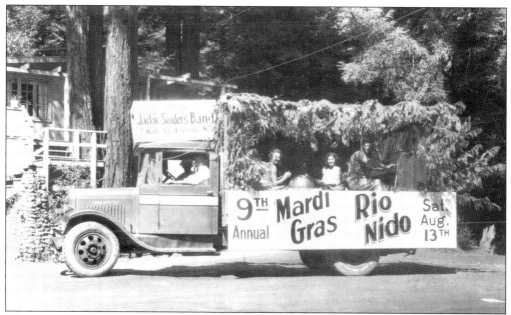

Musicians put the piano on a flat bed truck and cruised the canyons of Rio Nido, advertising the Ninth Annual Mardi Gras, featuring Jackie Souder's band; the ad above the cab promises "Two Weeks Vacation in One Nite!" (Courtesy of John Schubert.)

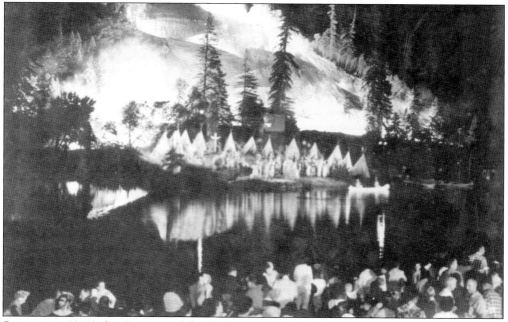

Starting in 1948, the Pageant of the Full Moon marked the end of tourist season. Dorothy Gugich, Olga Tyken, Marie de Smit, and Mildred Gallman created an "Indian" play to celebrate Indian summer, although their story, which ends with the mountain bursting into flame, is unrelated to local Pomo lore. Later the name was changed to Pageant of Fire Mountain. Staged across river at Parker's Resort, it was best viewed from Johnson's Beach. (Courtesy of the Sonoma County Museum.)

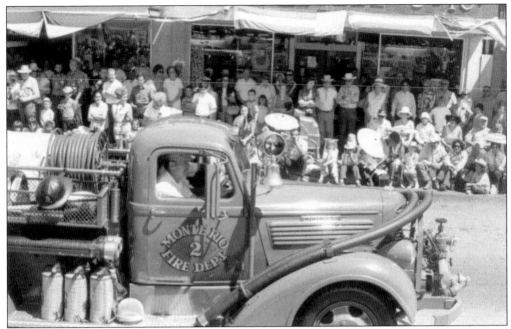

Guerneville's Stumptown Daze began just after World War II, created by locals Red Standish and Joe Sessler as a way of announcing that summer had arrived and it was time to start enjoying some serious recreation. The first annual Daze in June 1946 included a parade starting at Henry Hess' lumberyard at the eastern end of town. Tom King Sr. was the first grand marshal. Entries came from nearby towns, like this Monte Rio fire truck cruising past the Guerneville 5 & 10. (Courtesy of John Schubert.)

Stumptown Daze activities included gambling, a logging competition, and a whiskerino contest (left) for local bearded fellas, like George Guerne (on the right). Prizes were awarded at the Grove Dance Hall. People came in costume, and one Guernevillian dressed as a rag-tag logger became the model for the Stumptown logo, Stumptown Sam. The Russian River Jaycees put on the last Daze in 1972, although the parade continues. (Courtesy of John Schubert.)

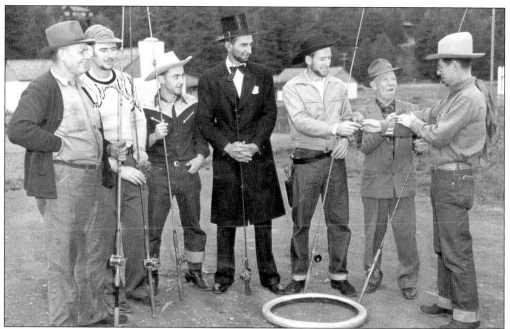

The Lions club sponsored the Stumptown Plug-casting team for the 1947 Stumptown Daze. Those trying their luck were, left to right: Harry Braun, Grant King, Bob Zopi, (?) Clark (a.k.a. Honest Abe), Ed Martin, John "Shorty" Parkins, and Paul Mitchell. Parkins came to the River from southern California in 1912 and was an avid member of the Sportsman's Club in Duncans Mills. In 1984, at the age of 100, he served as Grand Marshall of the Stumptown parade. (Courtesy of John Schubert.)

Of all the River's quirky festivals, the weirdest was the Slugfest, sponsored by *The Paper* during the 1980s. Honoring the slimiest of local fauna—the banana slug—this annual spring festival included slug races (think snail's pace) and the chefs' delight, the Slug-Off. Local politicians proved what good sports they were by judging entries like slug stroganoff. Congressional aide Nick Tibbets (left) and assemblyman Dan Hauser (wearing slug bib) survived the 1983 tasting at Northwood Lodge. (Photo by Simone Wilson.)

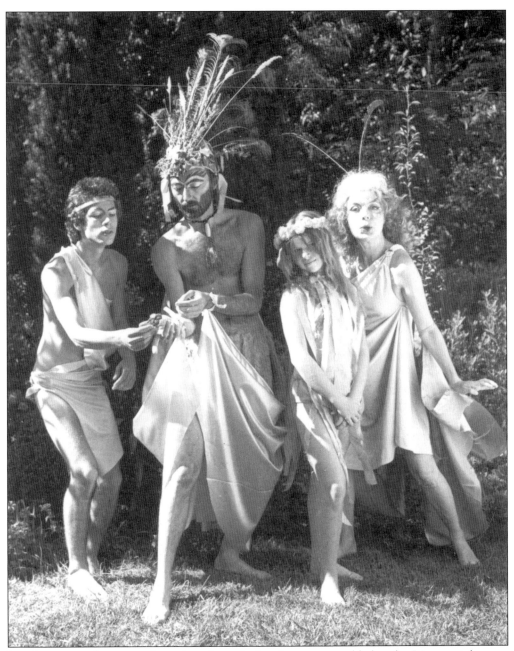

Local repertory theater, performed outdoors during the summer, added to the River social scene. In the 1980s the River Players (later River Repertory Theatre) brought Shakespeare to the redwoods, performing *Twelfth Night* on the riverbank and *A Midsummer Night's Dream* (above) at the amphitheatre in Armstrong Woods, August 1982. Appearing, left to right, are David Shapiro as Puck, Michael Tabib as Oberon, Angela Clark as a fairy attendant, and Darlene Kersnar as Titania the Fairy Queen. In the early 1950s, Armstrong Grove was also the home the Stumptown Players, a troupe of UCLA drama students who performed every summer to hone their skills; their most famous alumna is Carol Burnett. (Jack Shriber photo, courtesy of the River Repertory Theatre.)

Eight

HOMEGROWN CIVICS

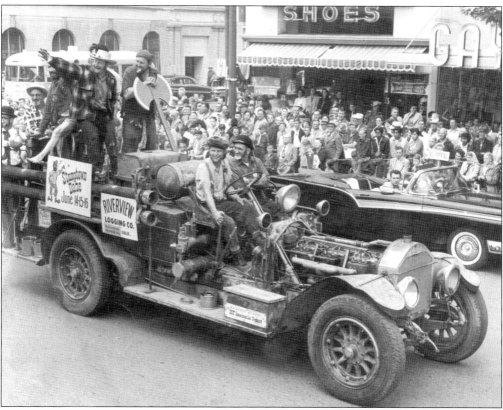

Since none of the lower Russian River towns is an incorporated city, citizens join together to form volunteer fire departments, fire lookouts, park districts, sports teams, and theater groups. Guerneville's earliest fire truck, a 1917 American LaFrance, joins a parade at Santa Rosa's Courthouse Square to promote Guerneville's annual summer whing-ding, the June Stumptown Daze. The sign behind the driver advertises Riverview Logging of Cazadero. Floods could be anticipated to some degree; the more menacing scourge—as with most early towns built of wood—was fire. A cookstove fire in August 1894 destroyed much of Guerneville, although the school, the bridge, and Connell's livery escaped the blaze. A March 12, 1906, fire razed the Grand Central Hotel and seven other buildings on the south side of Main. A probable arson on September 25, 1919, destroyed Guy Laws' billiard parlor, a dry goods store, and the home of then fire chief Newton Lark. (Courtesy of John Schubert.)

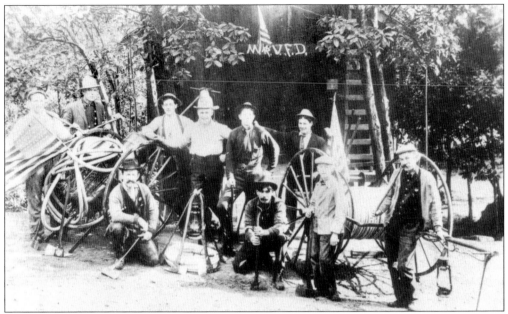

Members of the Monte Rio V.F.D. posed for their group portrait, March 6, 1910. Pictured here, left to right, are: (front) Bill Hewelke, Joe Ferrio, Milton Meadows, and Charlie Meadows; (back) Harry Duff, Lee Weaver, Fred Krutzberger, Dick Campbell, Chris Hartman, and Eddie Jones. (Courtesy of the Monte Rio Historical Society.)

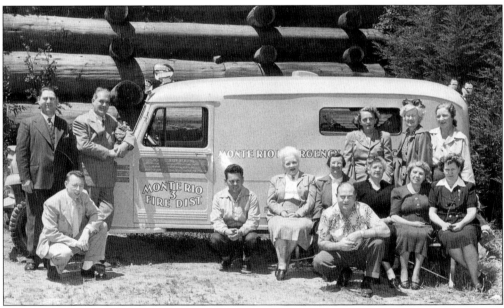

Red Cross volunteers joined with Monte Rio VFD to dedicate the John Haussman Memorial Ambulance, April 1951. Haussman was the first local to die in the Korean War. Pictured on the left are Al Bohny, Gilson Willets, and Lee Torr III (kneeling). Seated, from left to right, are Harry Burke, (?) Scott, Dorothy Meadows, Emma Hess, Mary Balish, Marge Pedroia, and Charles Rickett in front. Standing at the right are Lois Fulkerson, Inez Litton, and Florence Crawford. (Maury Darr photo, courtesy of the Monte Rio Historical Society.)

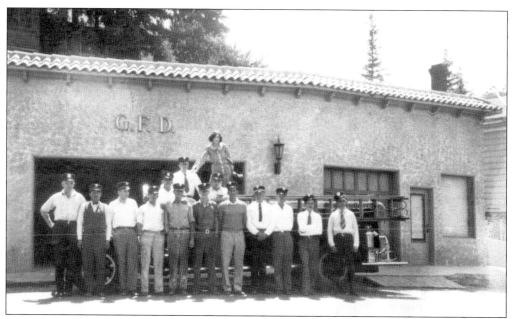

Inspired by the massive 1923 fire that threatened the town, locals insisted on a tax-funded Guerneville Fire Department. Posing in 1928 with the fire truck are, left to right: (front) Bernard Sears, Frank Lambert, Ran Starret, unidentified, Cris Baagoe, Joe Petrini, Harold "Cap" Trine, unidentified, Homer Beach, and Bill Kenyon; (back row) Ralph Marshall, unidentified, and Frank Gori. Atop the truck is Ella Kinman. (Courtesy of John Schubert.)

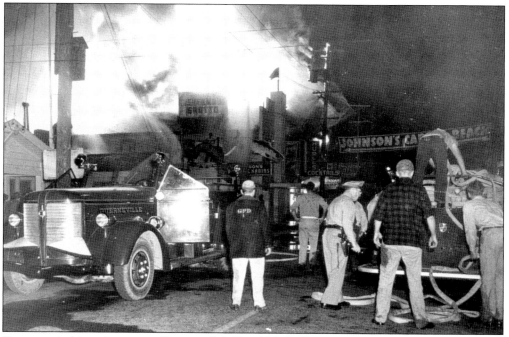

Firemen tried in vain to save Guerneville's Hotel Nicholls during a July 1947 blaze. The scene is the south side of First Street, looking west, near the entrance to Johnson's Campground. (Courtesy of John Schubert.)

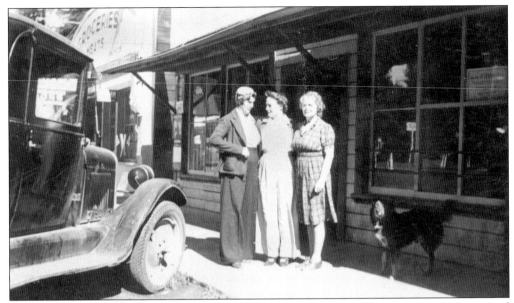

Many post offices were part of a larger establishment, usually a store. Small towns often acquired an official name with the opening of a post office. The post office was a natural meeting place for friends and neighbors. Here Hazel Batt, Olive Bush, and Lois Post stop to chat in front of the Monte Rio Post office, c. 1937. (Courtesy of the Monte Rio Historical Society.)

Lena Kocker was postmaster of Mesa Grande (now called Villa Grande), on the south side of the River between Monte Rio and Duncans Mills. (Courtesy of the Monte Rio Historical Society.)

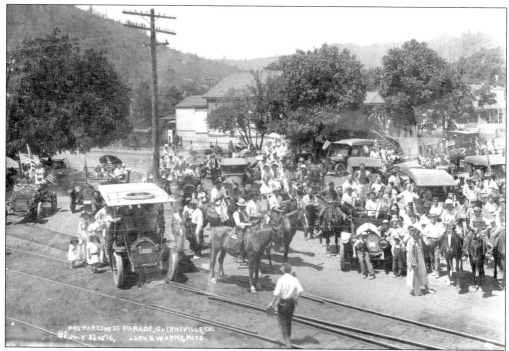

Fourth of July and other patriotic parades were popular on the River; most of Guerneville turned out for this World War I preparedness parade on July 22, 1916. Guerneville had 28 men at the front in World War I, including ambulance driver Henry Sousa, the man who served in the most battles in France. The local VFW Post was named for Jack Coon, who died while serving in the Army. (Newton Lark photo, courtesy of John Schubert.)

On the home front during World War II, townspeople sold bonds to support the war effort. Marie Balish, Johey Korke, Florence Crawford, Mrs. Comerford, Zella Hembree, A. Northern, Lois Degen, Monte Rio postmaster Olive Richardson, and Monica Hiller gathered at the Monte Rio Post Office. (Courtesy of the Monte Rio Historical Society.)

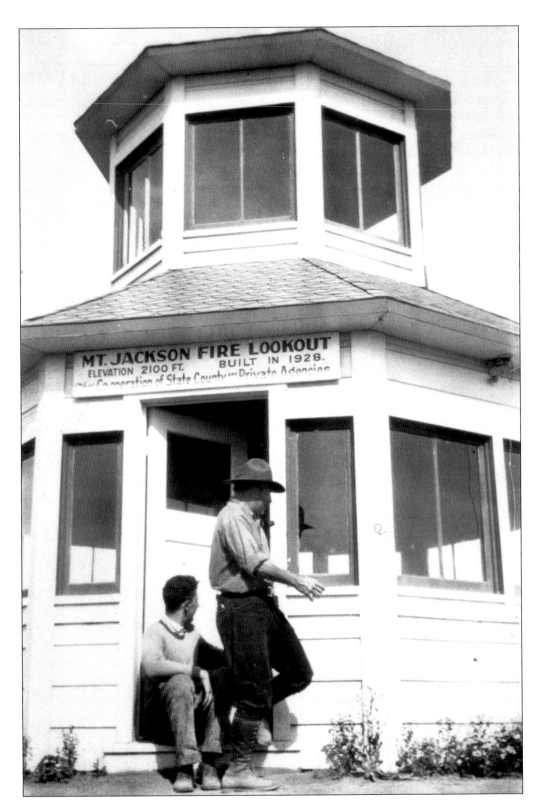

MT. JACKSON FIRE LOOKOUT
ELEVATION 2100 FT. BUILT IN 1928.
In Co-operation of State County and Private Agencies

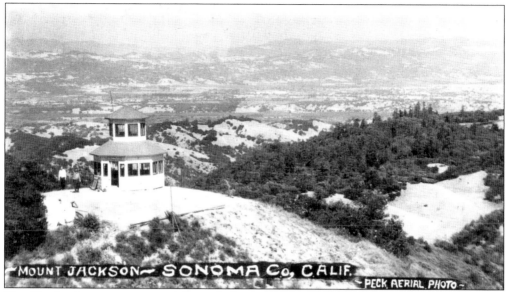

MOUNT JACKSON~ SONOMA Co, CALIF.
~PECK AERIAL PHOTO~

The Fire Lookout station atop Mount Jackson (facing page and above) was the first line of defense against summer brush fires. From the station at 2,100 feet, lookouts had a view of the whole Santa Rosa Plain to the southeast, as well as the hills around Guerneville. Lookouts spent the dry summer season watching for signs of smoke so they could alert fire crews. This 1928 building was replaced by a modern one, but the lookout station was closed for lack of funding in the 1990s. (Courtesy of John Schubert.)

With the closure of Mt. Jackson station, the only remaining west county lookout station is at Pole Mountain, funded privately by the community of Cazadero. Here lookout Tina Parmeter scans the hills for signs of brush fires, c. 1982. (Photo by Simone Wilson.)

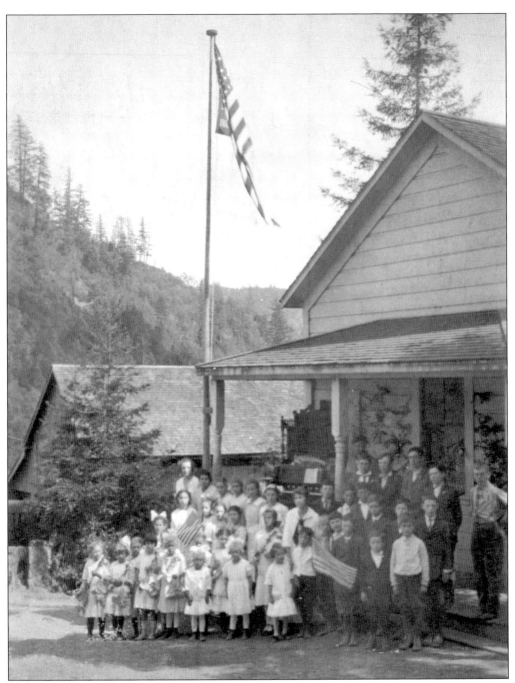

Students posed in front of Sheridan School west of Monte Rio for Flag Day, *c.* 1915. Teacher Mae Gleason (later Mrs. Tom Furlong) is in the center, in white. Girls present include: Loazbel King, Frances Sietz, Josephine DelBuddhia, Alice Sheridan, Regina Noethig, Adelma O'Laughlin, Gussie O'Laughlin, Elizabeth Sheridan, Loretta Noethig, Mary Landers, Janet Nickerson, Freda DelBucchia, Frieda Noethig, Ruth Sheridan, Lillian DelBucchia, and Kay Odell. Boys included: Virgil Breen, George Odell, Frank O'Laughin, Harry Torr, Walton Odell, Tom Ahern, Guido DelBucchia, and Lee Torr Jr. (J.B. Rhea photo, courtesy of the Monte Rio Historical Society.)

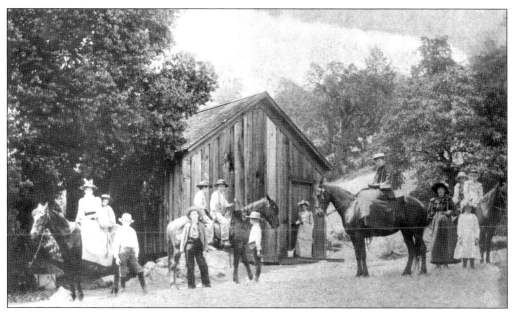

Students of the first Montgomery School, about two miles north of Cazadero, met at the schoolhouse on the Dorothy Baines property. One of the teachers, the mother of the future Judge Geary, had to shoot a wildcat lurking in the rafters of the schoolhouse one morning before proceeding with lessons. Today's Montgomery School is just north of town on Fort Ross Road. (Courtesy of the Sonoma County Historical Society.)

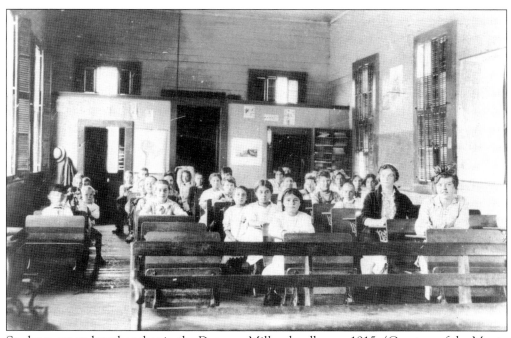

Students sat on long benches in the Duncans Mills schoolhouse, 1915. (Courtesy of the Monte Rio Historical Society.)

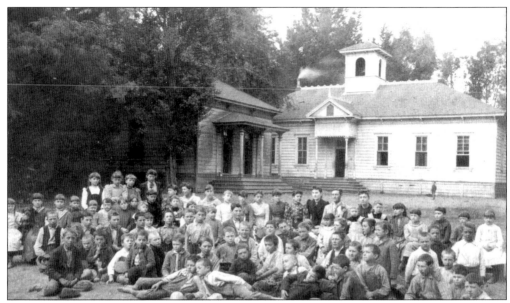

Three teachers (back row, right of center) at Guerneville School, 1893, are, left to right: Miss Talmadge, Principal Brairity, and May Burke. The boy lying down at center is Art Coon. Two girls on far left are Gertrude (Lautren) Shulte and, holding her dog, Gretchen (Ungewitter) Belden. (Photo by W.W. Collom of San Francisco, courtesy of John Schubert.)

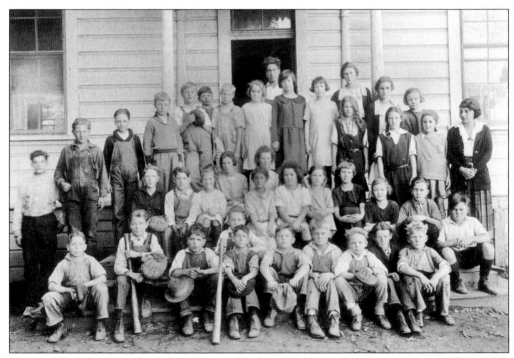

Guerneville School was built in 1882 on the site of the first school, which was built c. 1865. The new school had two classrooms and a principal's office; a third classroom for primary grades was added in 1884. Above is the class of 1921. (Courtesy of the Sonoma County Museum.)

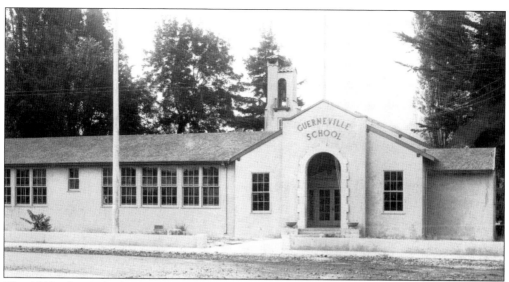

The 1882 school also burned down and was replaced in 1923 by another Guerneville School, at the corner of First and Church Streets. In 1949 the district built a new grammar school north of town off Armstrong Woods Road, and the former school became the Guerneville Veterans Memorial Building, a venue for choir practices, community dinners, and town meetings. Guerneville briefly had a junior high at Pells Resort on Mill Street. Two classes met in the dining room and a third convened in the kitchen. Ovens and kitchen cabinets served as student lockers. After 1926, the eighth and ninth graders went to Analy High in Sebastopol. (Courtesy of John Schubert.)

Besides the town schools, numerous one-room schools were scattered among the hills and valleys. Mountain View was in Pocket Canyon; Madrone School was between Guerneville and Cazadero. Ridenhour School was between Forestville and Guerneville. Mount Jackson School, 1878–1936, served miners' kids; Summit School (near Bullfrog Pond in Austin Creek State Park) operated until the 1920s. During recess, boys like this 1921 Guerneville School student brought mitts and bats to school to play baseball. Girls' favorites included games like London Bridge, Button-Button, and One Foot in the Gutter. (Courtesy of the Sonoma County Museum.)

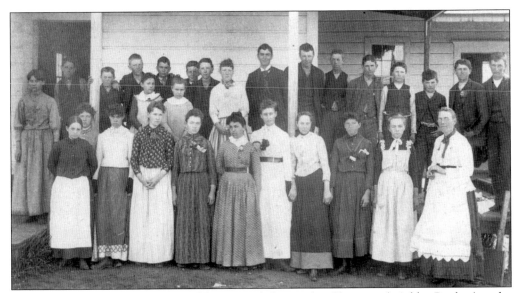

Forestville school students pictured here, are, left to right: (front row) Addie Banks (on the steps), Grace Foster, Jennie Johnson, Stella Marley, Nora Clover, Abbie Johnson, Hettie Harfine, Tina Sinclair, Annie Ross, Nellie Ross, Celesta Hutching, and teacher Mrs. Butler; (on the porch) Edith Clark, Edith Ritchlieu, Emma Shamberg, and Dora Bacon; (back row) George Butler, Harry Ross, Walter Ricket, Bert Jewett, Mark Ricket, Frank Fallon, Frank Jewett, Ira Fallon, Pressley Marley, Clyde Hewett, Harmon Covey, Will Chency, Arthur Ross, and Don Williams. (Courtesy of Lorraine Owen.)

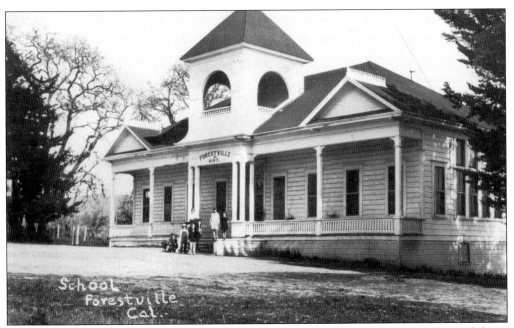

Forestville's 1899 school (above) was on the site of the current school. When it burned down in 1934, town carpenters formed an impromptu construction association and in a matter of months built a new one, which still forms part of the campus. (Courtesy of the Forestville Historical Society.)

Forestville School's class of 1916, posing for their graduation, are: (front row) Alice Williams and Alta Williams; (middle row) Kenny Templeman, Art Orchard, Naomi Gillespie, unidentified, Helen Wakeland, Westwood Case, and Helen Ross; (back row) unidentified, Hilda Anderson, Don Scott, Frances Stratton, Leo Hansa, Margaret Silk, unidentified, and Gladys Havenstrike. (Courtesy of the Forestville Historical Society.)

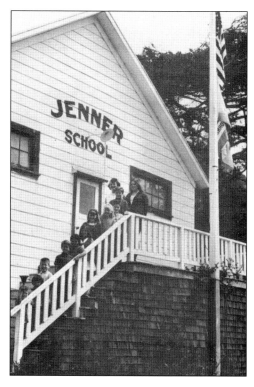

Students lined up on the stairs for Jenner School's final graduation on June 7, 1969. At the top are teacher/principal Vivian Zipperian and the sole eighth grader, Lynne Doraine Sommer. The other kids on the stairs are Alan, Kathleen, Robert, and William Johnson, Margorie Mann, Edward and Omar Perez, Aaron Sait, and Kristen and Steven Smith. The school ran from 1904 to 1969; its teachers were Maybelle Charles, Annie von Arx, Ella Harrison, Lucile (Armstrong) Cuthill, Alice Ashbrook, Hubert Hansen, B.E. Price, Virginia Williams, and Vivian Zipperian. Cuthill served by far the longest time: 1916–1919 and 1924–1964. In the early years she lived in Cazadero and rode across the hills on horseback to get to school. (Courtesy of Elizabeth Mann.)

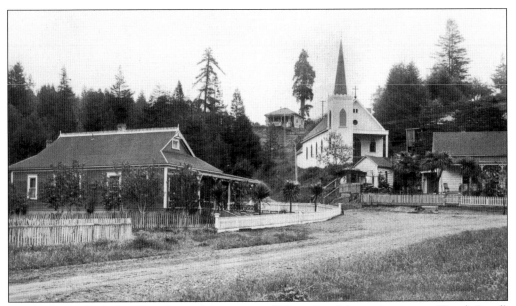

St. Elizabeth's Catholic Church, near the corner of Mines Road (now Armstrong Woods Road) and Fourth Street, was built in 1906, largely with volunteer labor, on land donated by Ivon and Elizabeth Clar. The pews came by wagon from Sebastopol. This photo is c. 1910. The quake of 1906 occurred while the church was under construction. The current St. Elizabeth's opened on the same site in July 1938. (Courtesy of John Schubert.)

The Breen family donated the land for Monte Rio's St. Catherine of Siena Catholic Church. The church was built in 1912, in large part at the request of Bohemian Club members, who wanted to avoid the five-mile trip to church in Guerneville. An annual Bohomian Club show helps raise money for the church. (Courtesy of the Monte Rio Historical Society.)

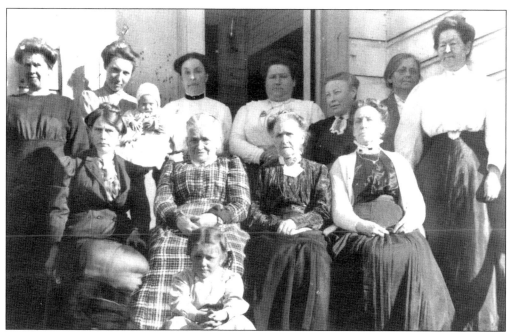

The ladies of Guerneville's Methodist Church, 1912, included, standing left to right, Mrs. Ayers, Mrs. Menker (the minister's wife), Mrs. Body, Mrs. Kistner, Mrs. Trine, Mrs. Drake, and Mrs. Brown. Seated in front are Mrs. Miller, Mrs. Crocker Yarborough, Mrs. Finley, and Mrs. Campbell. The children in front are Lena Belle Miller (in white dress, facing camera) and Ora Duncan. (Anna Beaver collection, courtesy of John Schubert.)

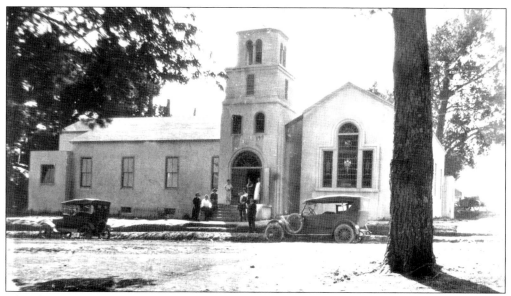

Churchgoers parked in front of Forestville's new Methodist Church in 1924, the year it opened at the corner of Covey Road and Center Street. (Courtesy of the Forestville Historical Society.)

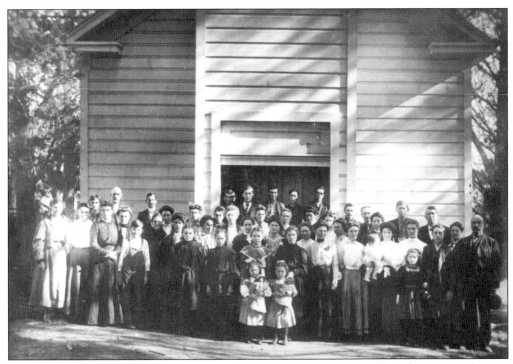

Forestville's Church of Christ, pictured here 1908, was built in 1878 and is said to be one of the oldest continuously meeting congregations in California. (Courtesy of the Forestville Historical Society.)

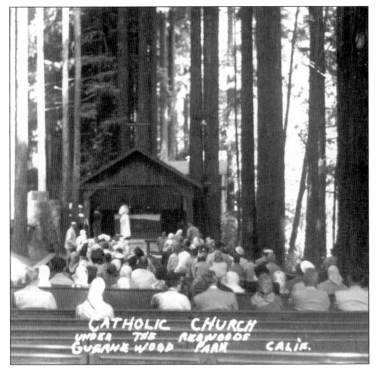

CATHOLIC CHURCH
UNDER THE REDWOODS
GUERNE WOOD PARK CALIF.

Although Guernewood Park itself had no official church, summer mass was held under the redwoods at this outdoor chapel, *c.* 1955. Guerneville Community Church was founded in 1895. For 70 years it was on First Street and then moved to the current site on Armstrong Woods Road, where a piece of a 2,000-year-old redwood serves as the altar. (Courtesy of John Schubert.)

Nine

HIGH WATER

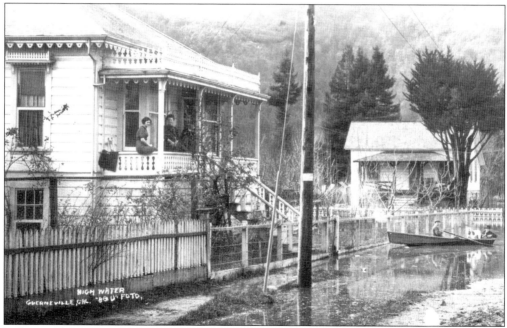

Jack Hetzel, his dog Sport, and Mrs. George Guerne took advantage of high water to go rowing in Guerneville following a 1910 storm. At left, Emma McPeak and an unidentified friend sit on the porch of the McPeak home. Winter storms offered rare opportunities for photography as well as paddling. If there are plenty of Russian River flood photos, it's not because the River floods constantly, but because people got out their cameras during the high water. The floods were, so to speak, newsworthy, and anyone with a Brownie box camera hauled it out to snap pictures of such a dramatic event. (Hetzel collection, courtesy of John Schubert.)

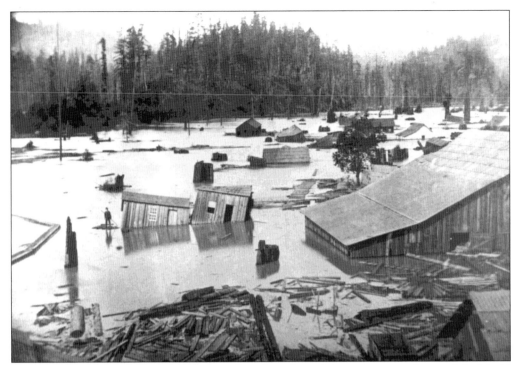

During the flood of 1879, several Guerneville cabins floated downstream, and part of the Heald and Guerne Mill slipped into Fife Creek, although the mill shop was saved when workers tied it to some nearby stumps. (Courtesy of the Sonoma County Museum.)

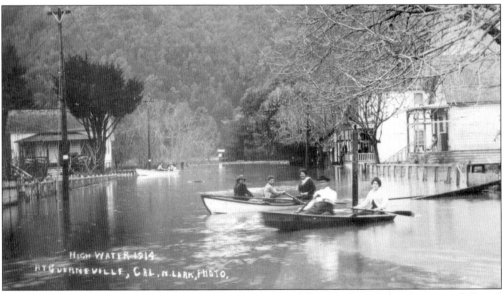

High water turned Guerneville's Fourth Street into a lake in 1914. School principal David Lockton and his wife Beatrice paddle the boat in front; behind them are Nattie Pells, her son Gene Pells, and Mrs. Frank "Dosia" Murphy of Murphy's Resort (later Fife's). Ed Peugh's house is on the left. Dave Hetzel's house is on the right; behind it is Guidotti's Garibaldi Hotel (later Buck's). (Newton Lark photo, courtesy of John Schubert.)

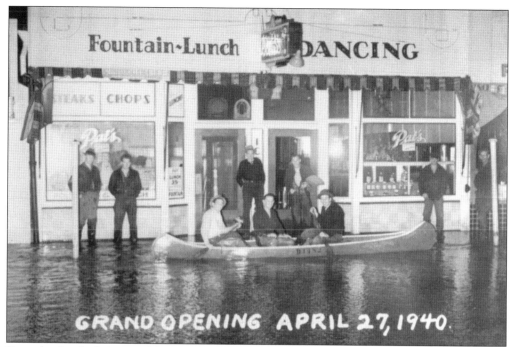

Even the flood of 1940 couldn't dampen River folks' enthusiasm for the food at Pat's Cafe on its opening day, April 27. The Hines family has run the cafe since 1943. At one time the interior had a long horseshoe-shaped counter, as well as a dance floor and a small stage for musicians. Pat's is still a fixture on Guerneville's Main Street. (Courtesy of the Sonoma County Museum.)

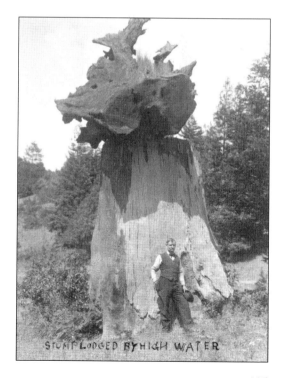

Winter storm waters are powerful enough to relocate tree trucks, old cabins, and even redwood stumps. The high water of 1879 left one stump perched upon another upstream from Guerneville. (Courtesy of Darlene Speer.)

125

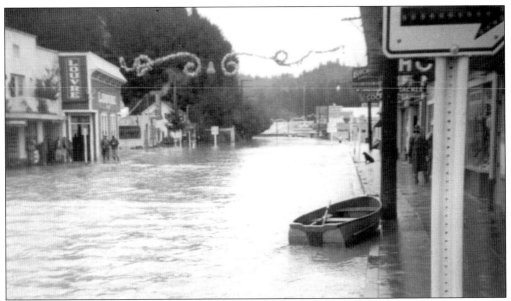

Water flowed down Main Street during a storm at Christmas time, 1955 (note decorations strung across the street). Several people, probably wearing high rubber boots, are standing in front of the Louvre, background left, at the corner of Main and Armstrong Woods Road, and a few more are walking down the sidewalk on the right. The view is east towards Rio Nido. (Courtesy of Darlene Speer.)

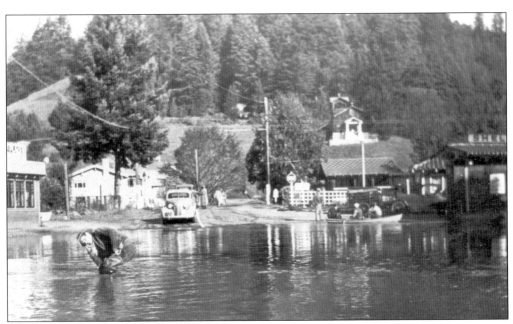

The street at the north end of the Monte Rio Bridge disappears beneath the high water on December 1937. Note St. Catherine's Catholic church up the hill on the right, and the Shell station on the far right, where the Rio Theatre is now. (Courtesy of John Schubert.)

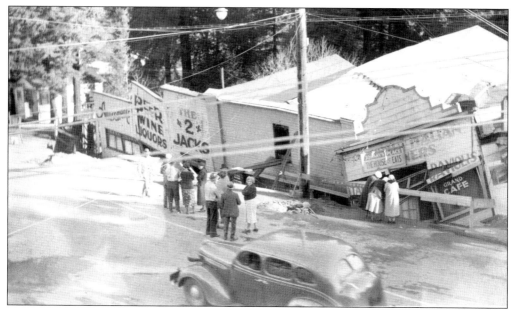

During the 1937 flood, the waters of Dutch Bill Creek undermined the foundations of several businesses just to the left of the Pink Elephant in downtown Monte Rio. Several buildings collapsed, including Johnny's Place, which served Italian dinners. After the wreckage was cleared away, pilings were put in to prevent further erosion. (Courtesy of the Monte Rio Historical Society.)

High water creates a perfect reflection at the Monte Rio Texaco station on February 5, 1937. The River hit 47 feet at the Guerneville Bridge that year. Other 20th-century flood years were 1940, 1955, 1964, and—the all-time whopper—the February 1986 flood. (Courtesy of the Monte Rio Historical Society.)

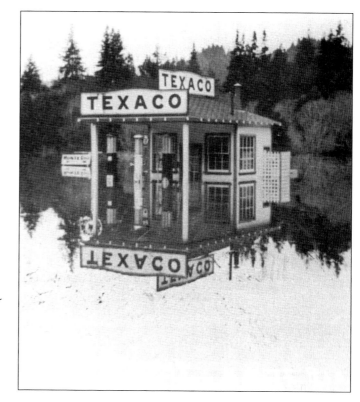

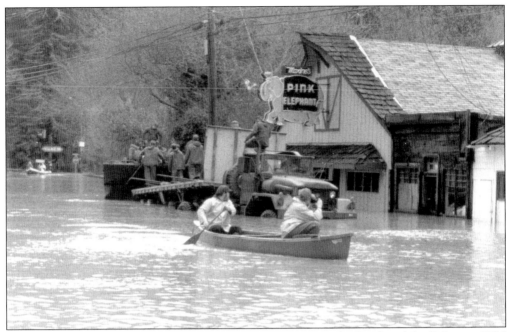

Two residents canoe past the Pink Elephant in Monte Rio at the height of the February 1986 flood; on the left are National Guard troops unloading a rescue boat. At the same time, in Guerneville, rescue helicopters airlifted 900 residents from the top of the hill near the cemetery to shelters in Sebastopol and Santa Rosa. (Photo by Simone Wilson.)

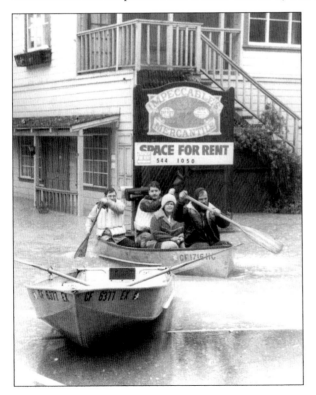

The February 1986 flood proved to be the highest recorded water in River history, topping out at 48 feet and 9 inches at the Guerneville Bridge. Here residents of the Neeley Road neighborhood paddle up to the south end of the Guerneville Bridge so they can cross to town. River Landing, the building in the background, was demolished after the flood, and in the 1990s engineers working on a new bridge rearranged the topography to raise the south approach above floodwaters. In Monte Rio, the grammar school near Dutch Bill Creek was abandoned and a new one built on high ground north of the River. (Photo by Simone Wilson.)